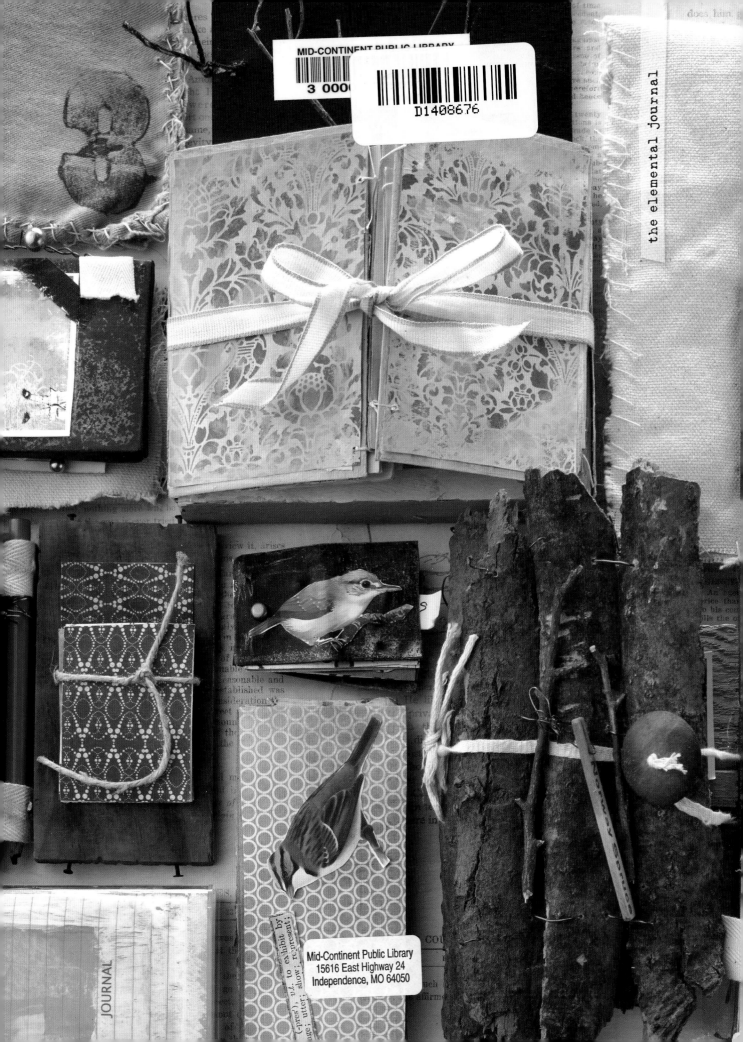

the elemental journal

JOURNAL

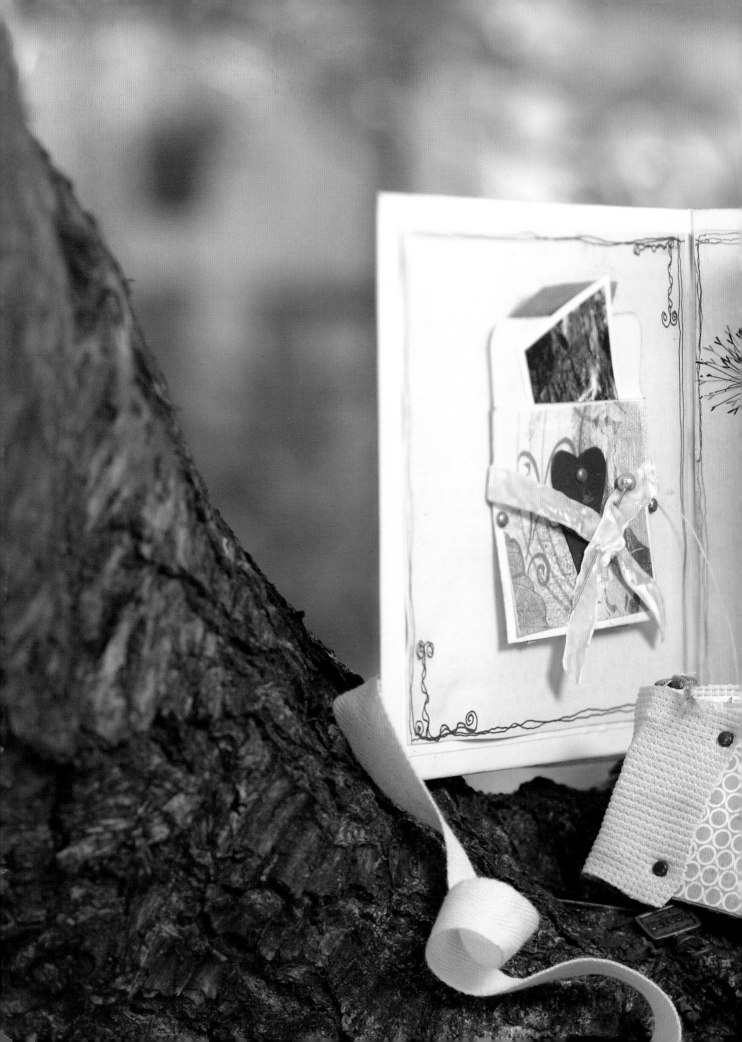

the elemental journal

composing artful expressions from items cast aside

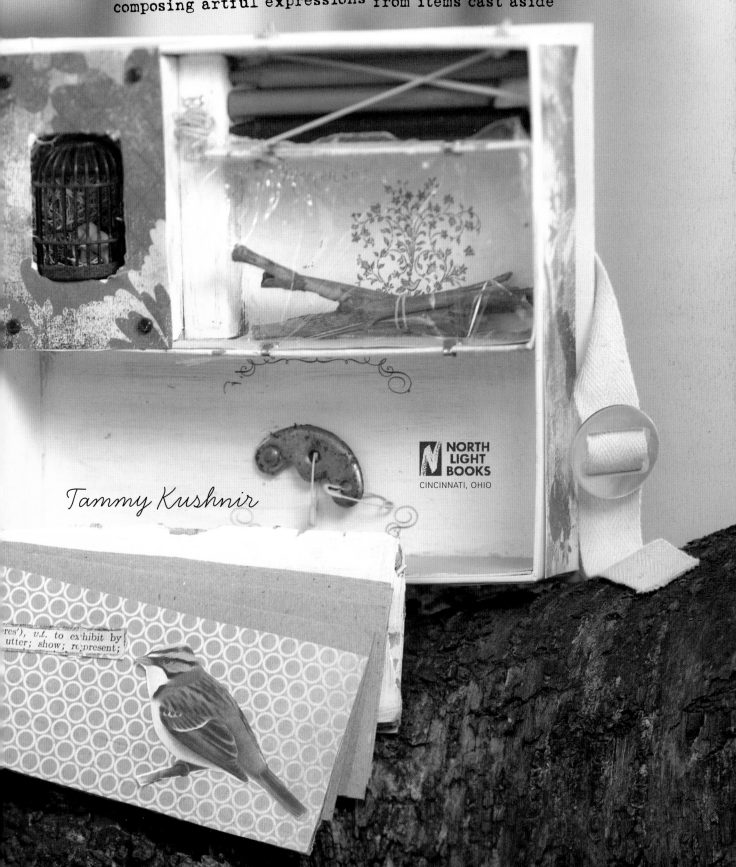

Tammy Kushnir

NORTH LIGHT BOOKS
CINCINNATI, OHIO

res'), v.t. to exhibit by
utter; show; represent;

15 14 13 12 11 5 4 3 2 1

DISTRIBUTED IN CANADA BY FRASER DIRECT
100 Armstrong Avenue
Georgetown, ON, Canada L7G 5S4
Tel: (905) 877-4411

DISTRIBUTED IN THE U.K. AND EUROPE BY F+W MEDIA INTERNATIONAL
Brunel House, Newton Abbot, Devon, TQ12 4PU, England
Tel: (+44) 1626 323200, Fax: (+44) 1626 323319
Email: postmaster@davidandcharles.co.uk

DISTRIBUTED IN AUSTRALIA BY CAPRICORN LINK
P.O. Box 704, S. Windsor NSW, 2756 Australia
Tel: (02) 4577-3555

Library of Congress Cataloging in Publication Data
Kushnir, Tammy.
 The elemental journal : composing artful expressions from items cast aside / Tammy Kushnir. -- 1st ed.
 p. cm.
 Includes index.
 ISBN-13: 978-1-4403-0536-8 (pbk. : alk. paper)
 ISBN-10: 1-4403-0536-6 (pbk. : alk. paper)
 1. Handicraft. 2. Found objects (Art). 3. Scrapbook journaling. 4. Scrapbooks. I. Title.
TT880.K87 2011
745.593--dc22
 2010037528

www.fwmedia.com

Editor: **Rachel Scheller**
Designer: **Julie Barnett**
Production Coordinator: **Greg Nock**
Photographers: **Ric Deliantoni, Christine Polomsky**
Stylist: **Lauren Emmerling**

metric conversion chart

to convert	to	multiply by
inches	centimeters	2.54
centimeters	inches	0.4
feet	centimeters	30.5
centimeters	feet	0.03
yards	meters	0.9
meters	yards	1.1

Special thanks to the Baker Hunt Arts and Cultural Center in Covington, Kentucky for their gracious hospitality in providing the photography location.

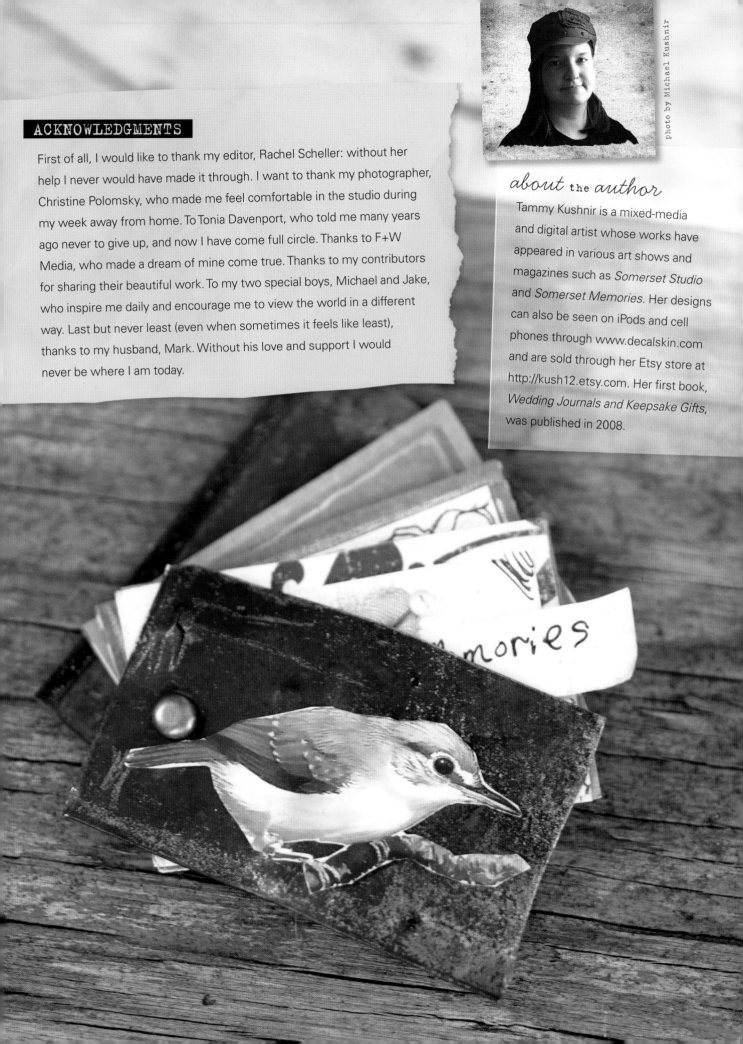

photo by Michael Kushnir

ACKNOWLEDGMENTS

First of all, I would like to thank my editor, Rachel Scheller: without her help I never would have made it through. I want to thank my photographer, Christine Polomsky, who made me feel comfortable in the studio during my week away from home. To Tonia Davenport, who told me many years ago never to give up, and now I have come full circle. Thanks to F+W Media, who made a dream of mine come true. Thanks to my contributors for sharing their beautiful work. To my two special boys, Michael and Jake, who inspire me daily and encourage me to view the world in a different way. Last but never least (even when sometimes it feels like least), thanks to my husband, Mark. Without his love and support I would never be where I am today.

about the author

Tammy Kushnir is a mixed-media and digital artist whose works have appeared in various art shows and magazines such as *Somerset Studio* and *Somerset Memories*. Her designs can also be seen on iPods and cell phones through www.decalskin.com and are sold through her Etsy store at http://kush12.etsy.com. Her first book, *Wedding Journals and Keepsake Gifts*, was published in 2008.

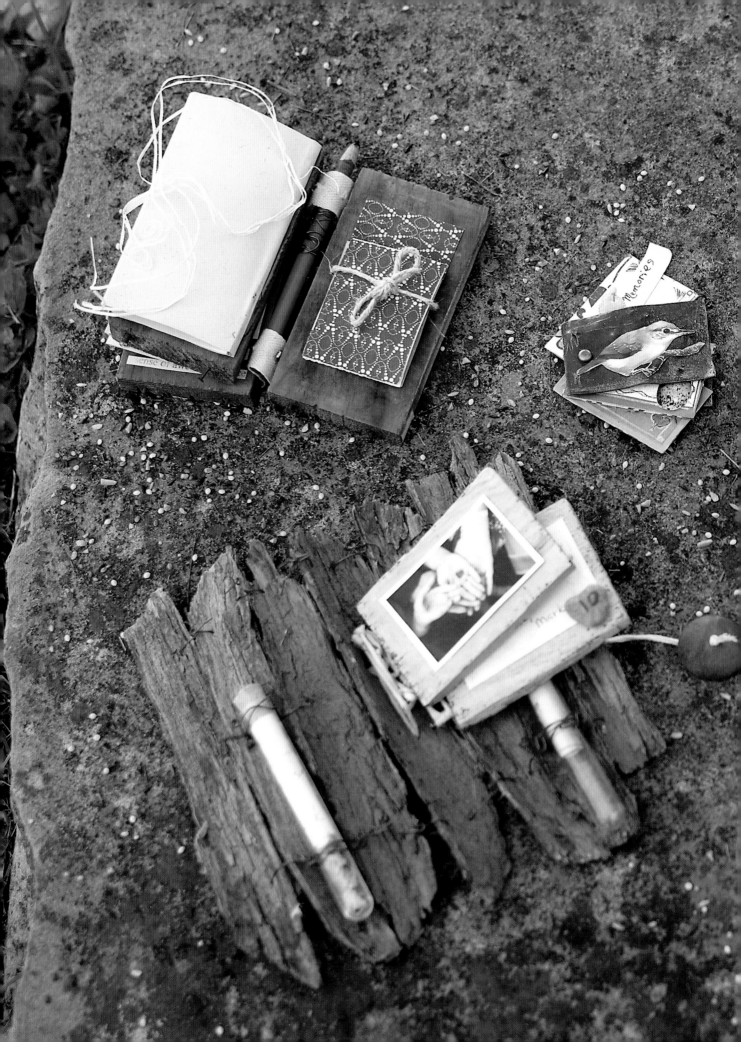

contents

introduction

I often get asked, *"Where do you get your inspiration?"* It is a harder question to answer than you would think. Over the years, I have learned to find potential in everything, from wooden scraps and tree bark to old doorknobs, plastic containers and newsprint paper. Now, mind you, I wasn't always like this. It took some training and optimism before I could see that silver lining and find my voice. I am still finding it even today.

When I first started out, I found inspiration in the works of others. Their pieces literally spoke to me. I saw inspiration in a good work someone had done for another or in a kind word spoken with intent. I felt inspired when my children surrounded me with their energy and unlimited imaginations. All these sources of inspiration filled me with the desire to create without hesitation. Though I had little experience at the time, I wanted to create works as amazing as ones by my favorite artists. I never let anyone tell me that I couldn't, and you shouldn't be discouraged either.

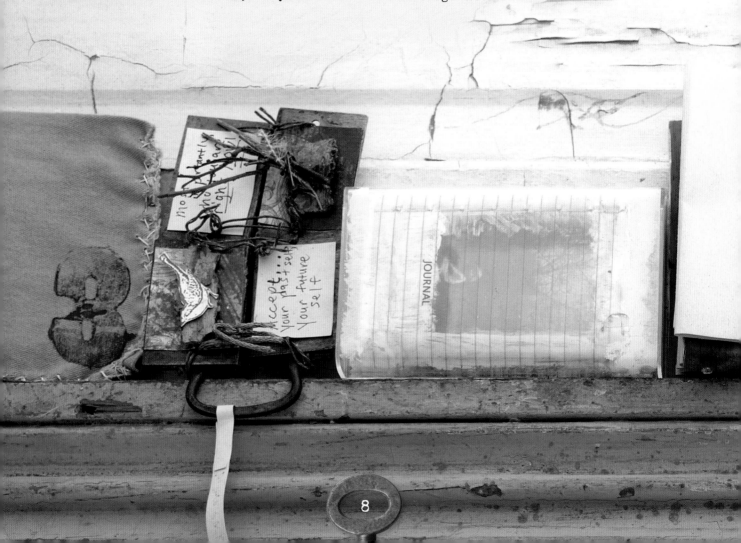

Throughout this book you will feast on projects that will hopefully aid you in your search for inspiration. You will find it in various sources, both external and internal. Personal battles and triumphs will be explored in imagery and writing in an attempt to draw your own experiences to the surface. None of us are unscathed and no one is beyond attaining bliss. Our deepest feelings are often overlooked, just as many of the castaway objects used in these journals are. However, once you discover them and really examine them, you will see something you never did before. You will find acceptance for yourself in your art-in-progress.

So go ahead, make these journals yours. Turn on music, or open a window to hear the birds. Breathe. If someone asks you, "Where do you get your inspiration?" while looking at one of your breathtaking pieces, you can smile because now you know.

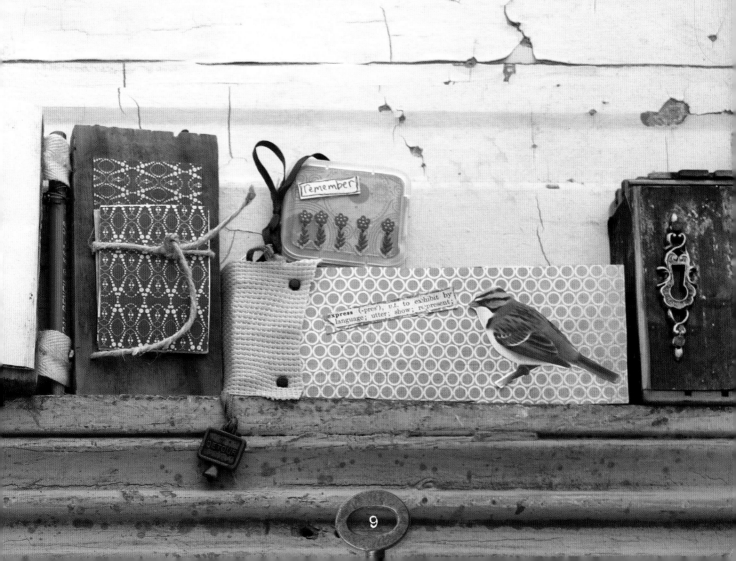

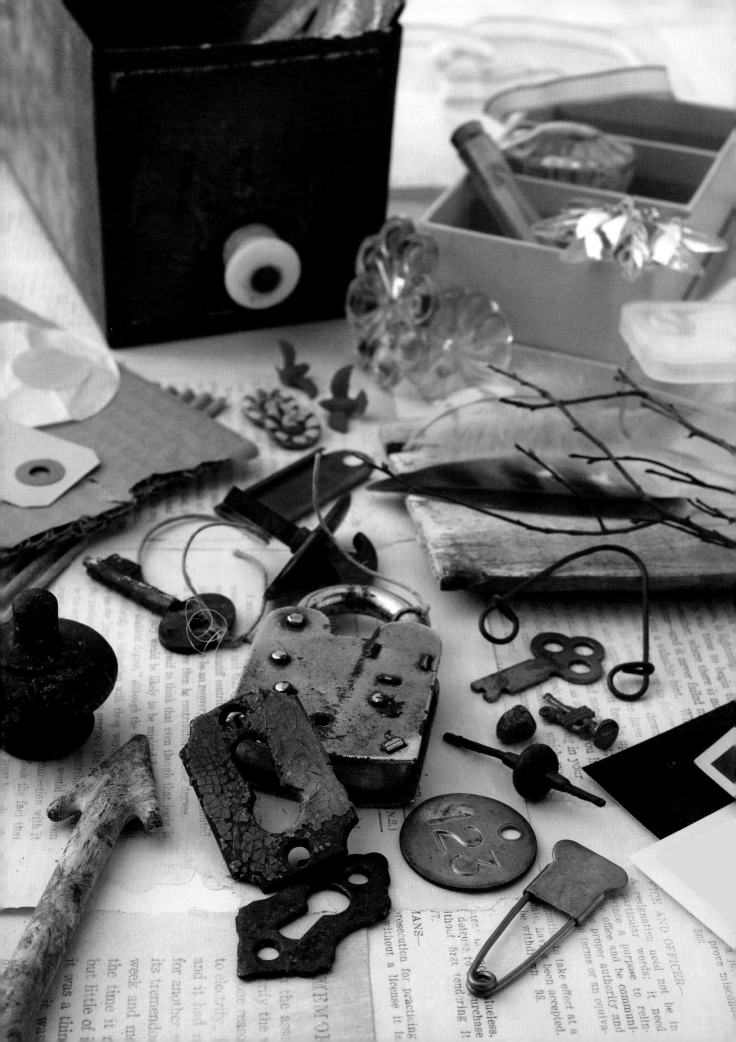

materials

The materials used in this book vary from store-bought items to objects we often come in contact with but are quick to overlook. The combination of the two can often result in beautiful and endearing projects that touch our hearts and the hearts of others. From paints and markers to rub-ons and corrugated cardboard, each item has its place in the types of journals you will see throughout this book. Colors can be muted or bright to reflect the mood of each journal and cater to the emotions of the artist who creates them.

Each journal has its own set of unusual found objects. When I come across a box or an embellishment, I immediately think up a purpose beyond what it was originally created for. For example, the box used in the *Stationery Set* (see page 66) once held smelling soaps and gels. The dividers were perfect "shelves" for holding store-bought findings as well as a finished journal for sketches and thoughts. For *Resurgam* (see page 54), I used a section of the box that once housed my Apple computer. The thickness provided a sturdy base and the various indentations and folds inspired me to create a home for my little book. I made the most of the box and recycled the rest: a two-for-one deal. For *Child Within* (see page 44), I used the plastic case from an Apple iPod touch. Plastic cases make great book covers: everything from hard plastic packaging to baseball card cases are versatile and easily incorporated.

When looking for materials to use, don't overlook the objects you would normally discard. This is your opportunity to give them a second chance. Every object has the potential to become something great—just like every artist.

FOUND OBJECTS

At flea markets:
* worn rubber strips
* boxes in all shapes and sizes
* vintage dictionary pages
* metal knobs, hinges, locks and keys
* miniature figurines
* rusted items
* glass bottles and vials
* vintage plastic charms
* vintage ribbon
* metal tins
* clock gears

In your home:
* personal photos
* old towels
* rubber bands and elastic hair ties
* spare buttons
* bobby pins

* sewing clips
* scrap paper
* patterned fabrics
* paper clips
* broken jewelry
* pressed flowers
* cotton balls

In nature:
* tree bark
* twigs
* feathers
* pebbles
* sand or dirt

In the trash:
* paper tags from clothes and toys
* plastic containers and packaging

STORE-BOUGHT MATERIALS

Fishing line or binder's thread

I found cotton fishing line at an antiques store. You can also find fishing line at bait and tackle shops or anywhere fishing supplies are sold. Binder's thread can be found at art supply stores. Both fishing line and binder's thread are used to bind books or attach findings to the journals.

Pencils (colored and regular)

Any type of pencil can be used in the projects in this book, from graphite and drawing to colored and pastel. I prefer Faber-Castell drawing pencils and Derwent pastel pencils. Both drawing and pastel pencils blend well and result in smoother color application. Use them instead of regular colored pencils to avoid a harsher look.

Rub-ons

Rub-ons are found at nearly every craft store and come in a variety of designs and fonts. They add a dash of color and interest to even the most basic projects. They create a union between the words and the images in a journal.

Transparency paper

Transparency paper can be found at office supply stores and some crafts stores. It is usually sold in bulk. Grafix has a reasonably priced transparency film that is sold in smaller quantities. Transparency paper is wonderful because it can be printed on, drawn on, or written on. Only one side can be used for these purposes or the ink will not stay on.

Newsprint paper

Newsprint paper is similar to doodling paper except that it is a shade darker. While it isn't always easy to find, it can often be purchased at crafts stores or art stores. If it is not possible to find, however, doodling paper makes a good, inexpensive substitute.

Patterned papers

Patterned papers can be purchased at crafts stores and scrapbooking stores. Choose patterns and colors that are unique to your style.

Wire

Wire can be good for many purposes, such as binding a book together or attaching findings without the use of glue. You can purchase various types of wire at local crafts stores.

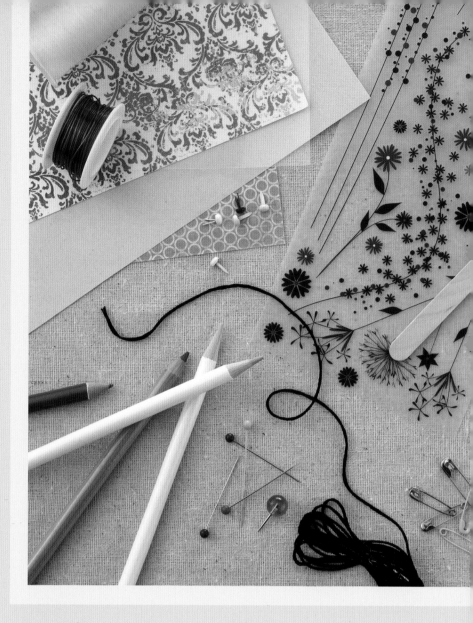

Fabric

Though you may choose to use fabric from torn or outdated clothing, you may also opt to purchase brand new pieces at fabrics or crafts stores. Crafts stores, as well as quilt and sewing shops, have aisles and aisles of fabrics in a variety of colors, patterns and blends. Since you probably won't be washing your journal, it is not necessary to wash purchased fabrics before using them in a project.

Brads

Brads can be found at office-supply stores. If you are looking for more than basic brads for your projects, check out a crafts store for various color and style choices.

Pins

Purchase unique, vintage-style or colorful straight pins and safety pins to attach pages or small findings to a journal in sewing or crafts stores.

Thread

Standard sewing thread is suitable for the fabric projects in this book. I also sometimes use embroidery floss or fine crochet thread for binding book pages or as an embellishment.

tools

Scissors

Different types of scissors are meant to do different jobs. Standard scissors get the job done, but I prefer KAI scissors for cutting most journal materials. They cut through fabric and paper very well, especially the hard to reach spots. (Keep a separate pair for cutting fabric so the blades won't be dulled.) Decorative scissors can turn any paper's edge into a work of art.

Craft knife

Craft knives can be purchased at hardware stores or crafts stores depending on the type you want. Utility knives are great for cutting cardboard and even book board. Some people prefer precision knives, which are smaller and used for projects that require extremely precise cutting.

Sewing needle

A sewing needle is needed for any thread you use—from fishing line to binder's thread.

Tape

Different kinds of tape can give a project a worn look or add a touch of beauty. Masking tapes, artist tapes and electrical tapes (available in many different colors) not only add a visual spark, but also attach pages or embellishments without glue.

Glue

I prefer to use a basic craft or tacky glue for adhering papers, but I wouldn't recommend using it for adhering metals or heavy objects. Search your local crafts store for appropriate substitutes.

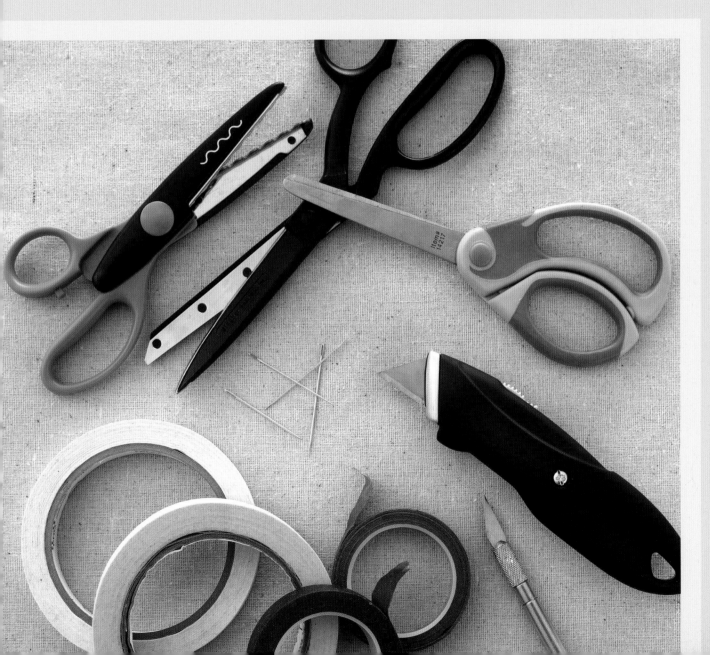

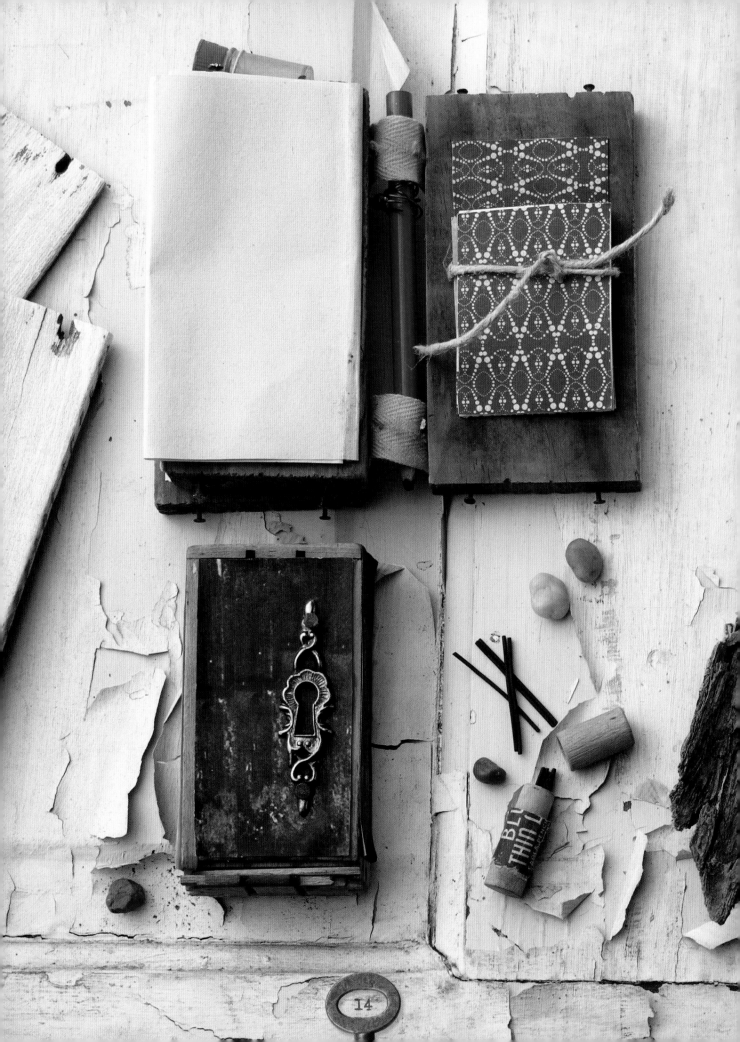

1 wood

The weight and texture of wood can be soothing. To place your hands upon one of the elements, to hold it and know that it came from the earth is a feeling profound in its simplicity. Wood in its basic form is calloused and worn, and parts of it can be brittle. Cradling it in our hands can remind us of our own humanity. Each journal in this section, from the *Sublime* drawing book (see page 16) to the little *Door Box* (see page 28), represents strength and beauty and a desire to discover a bit of inner peace.

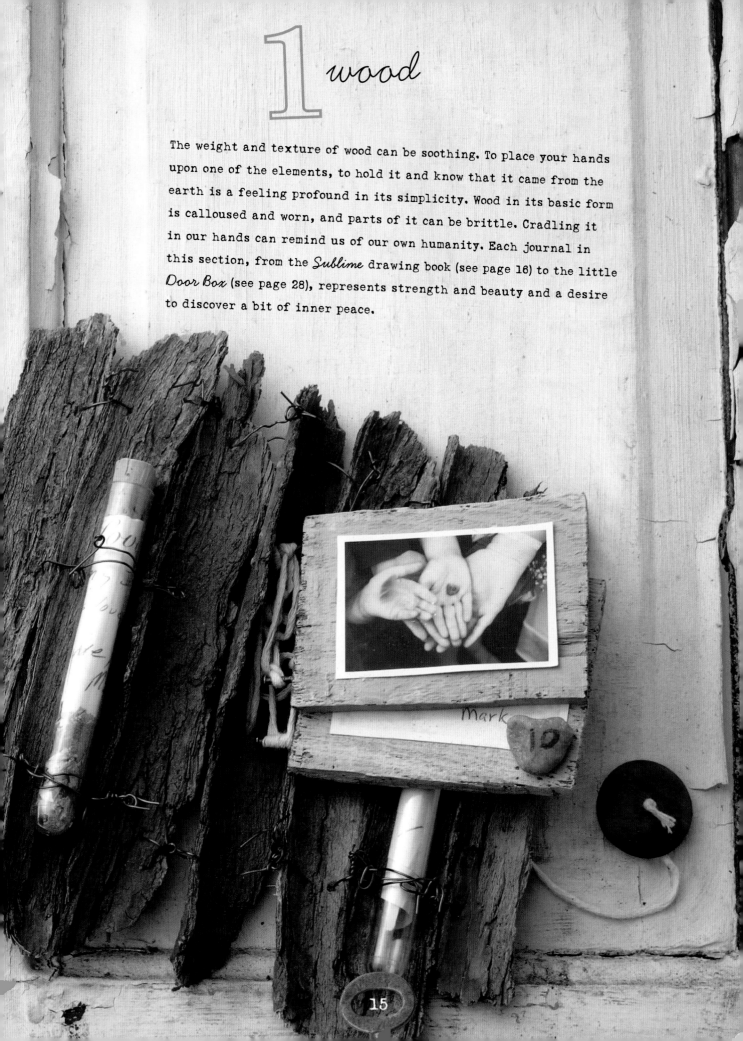

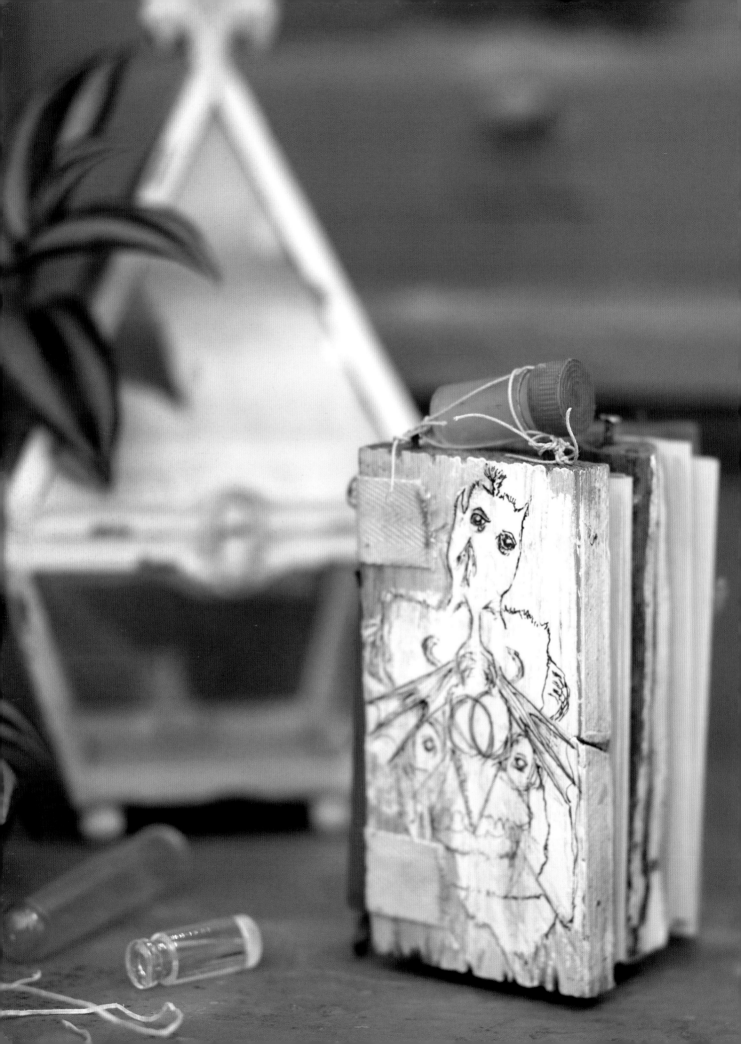

Sublime

Drawing is something anyone can do. Although some might be better than others at this particular skill, the original concept of art is not to compete, but to allow emotions to be felt and shared. This book was created with that purpose in mind. It holds a place for small sketches, a pencil and inspirational quotes to help you along the way.

{ CaST aSiDE }

Sublime was designed using an old cheese box found at a flea market. The box was held together by some rusty nails. I disassembled it and used the separated pieces for the cover and center page of the book. The worn nature of the box supplied a rustic ambiance.

MATERIALS

* 22-gauge copper wire

* acrylic paint

* black fine-tip permanent marker

* brads

* charcoal pencil

* cotton fishing line

* disc with quote

* Distress Ink in Tea Dye (Tim Holtz)

* metal finding

* mini glassine envelope

* newsprint paper

* paper clothing tag

* patterned paper

* rubber stamp with quote

* small nails

* small plastic vial

* straight pin

* twill tape

* twine

* wood pieces from a vintage box

TOOLS

* awl

* craft glue

* foam brush

* hammer

* scissors

* sponge for applying ink

* straightedge

1 Find a small wooden box that can be easily disas-
sembled and remove 3 pieces of equal size. These
will be the front and back covers and the center page
of the journal. If necessary, hammer 2 small nails into
the tops and bottoms of the front and back covers.
Hammer 1 nail in the side of the center page. In my
case, the nails were already there.

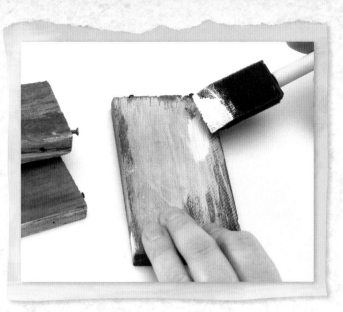

2 Using a foam brush, paint the front and back of each
piece in your desired color of acrylic paint. Use a
light shade so drawings can be added later.

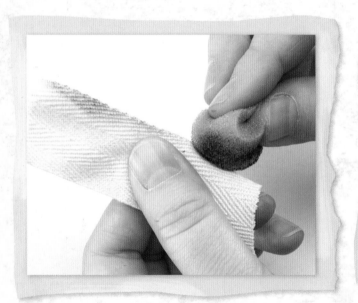

3 Cut 2 pieces of twill tape approximately 3" (7.5cm)
long and ink the edges with Distress Ink and a
sponge.

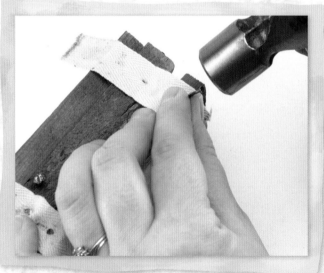

4 Stack the 3 wood pieces and turn them on their
sides. Make sure the nail in the side of the center
page is facing upward. Hammer the twill to the tops
and bottoms of each piece with nails.

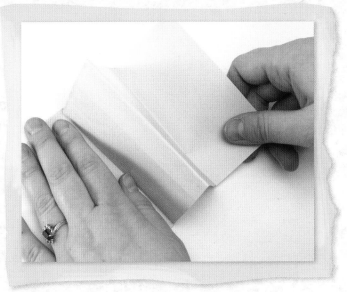

5 Measure the height and width of the wooden journal cover. Cut 2 pieces of newsprint paper that are 12" (30.5cm) long. The width of the papers should be equal to the height of the wooden journal cover. Accordion-fold each piece back and forth widthwise, spacing the folds so they are approximately the same width apart as the width of the journal cover.

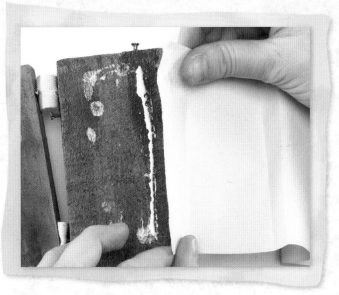

6 Glue a folded newsprint paper to each side of the center wooden page of the journal with craft glue.

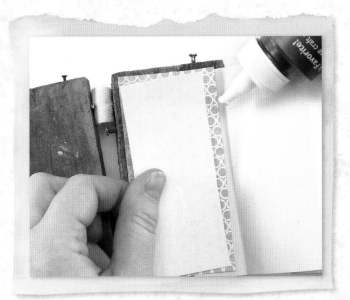

7 Unfold the newsprint paper. Cut pieces of patterned paper to fit the center wooden page. With craft glue, adhere them on top of where the newsprint paper is secured. Repeat on the other side of the center page.

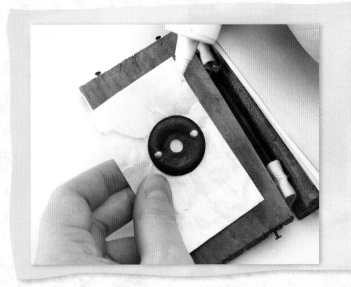

8 Attach a metal finding to the first layer of a mini glassine envelope with brads. Glue the envelope to the inside front cover. Add a straight pin to the envelope flap to keep it closed.

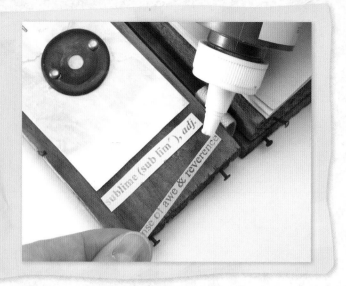

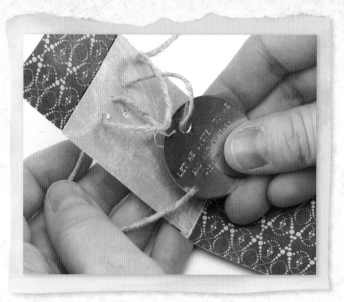

9 Stamp and cut out a quote and glue it under the envelope. I used the word *sublime* and its dictionary definition.

10 Cover both sides of a clothing tag with patterned paper. Using an awl, punch 3 holes across the center. Thread twine through the holes and attach a metal disc with a quote. Glue the tag to the inside of the back cover.

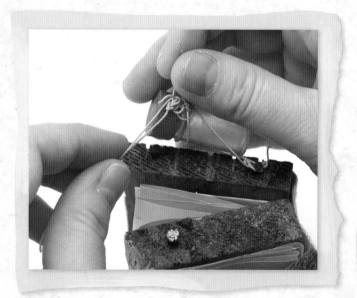

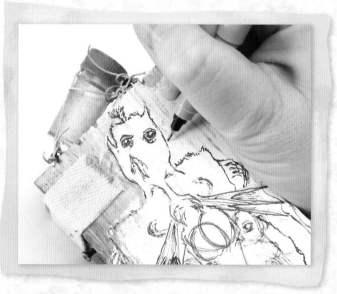

11 Using the nails in the top of the front cover, fasten a small plastic vial on the top using fishing line. This is a great place to hold small findings or a mini eraser.

12 Sketch a design on the cover with a black fine-tip permanent marker. For my sketch, I followed the lines of the wood to see where they would take my drawing.

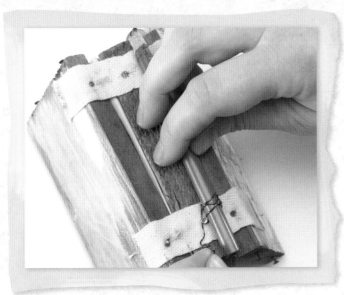

inspiring hint

You don't have to be in the most glamorous of settings to make art. If you let your mind wander, you can find that place without ever leaving your front door.

13 Using a piece of 22-gauge copper wire, attach a charcoal pencil to an exposed nail in the journal's binding. Wrap the wire tightly, but not so tightly that you can't slip the pencil in and out to use it.

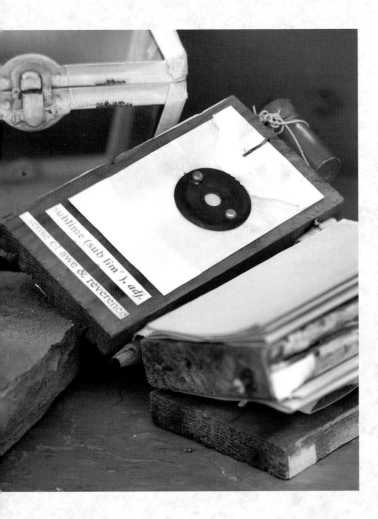

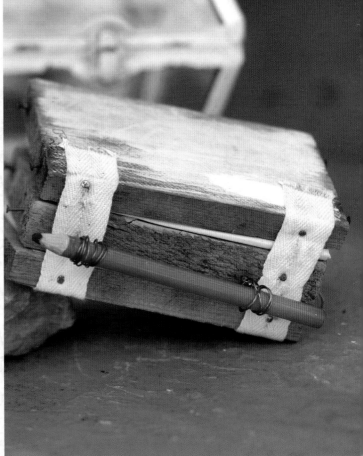

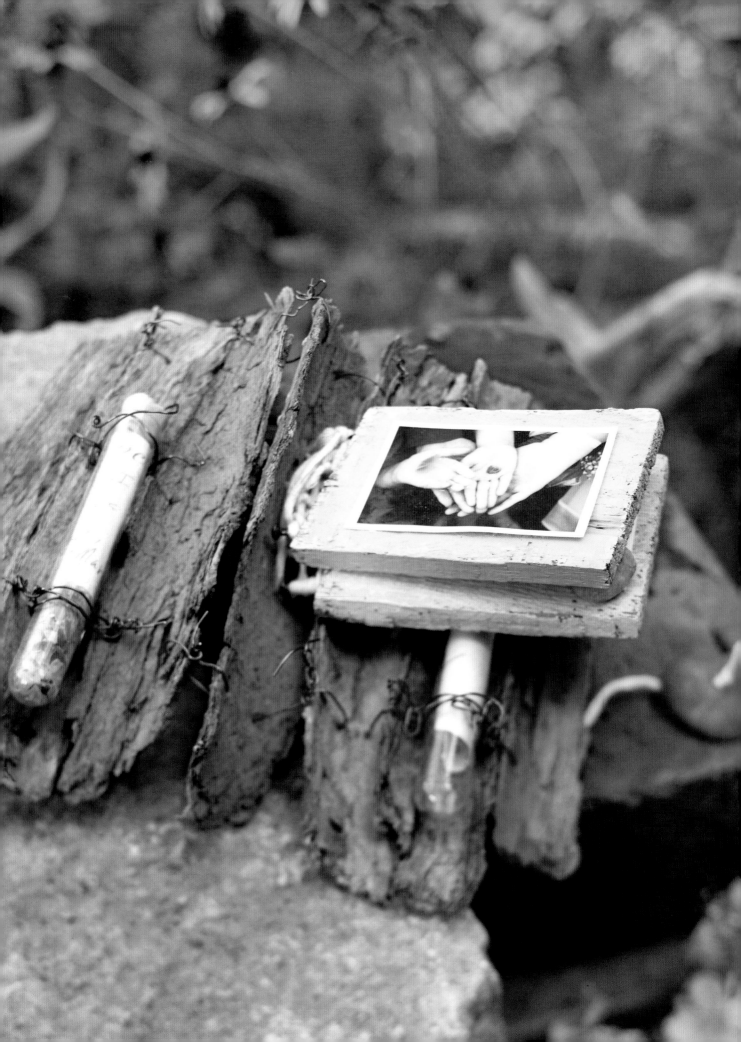

10

I have been married for ten years. Those years have been both long and short depending on the circumstances. For our tenth anniversary, my husband and I decided to do an impromptu wedding vow renewal with friends and family. I wanted to make a small book to commemorate this ceremony. It is also a place to hold some of the memories we've made through the years. So much has happened, both good and bad. However, the most important thing has remained: there is still an us.

{ CaST aSiDE }

I went "shopping" in my backyard with my son's help and found the bark used in this journal. You can find these abandoned strips in your backyard and local parks. If you choose to create a book this way, make sure you pick bark that's thick so it can withstand wear and tear.

MATERIALS

* 22-gauge copper wire
* acrylic paint
* images printed on photo paper
* love notes
* nails
* natural findings
* personal photos
* pieces from a wooden box, approximately 2½" × 3" (6.5cm × 7.5cm)
* plastic test tubes or vials
* string from curtains
* strips of bark, approximately 1½" × 7½" (4cm × 19cm)
* twigs
* wooden button with one hole
* wooden tag

TOOLS

* awl
* craft glue
* foam brush
* hammer
* scissors
* wood glue

1 To assemble the cover, use an awl to punch holes into 7 strips of bark measuring approximately 1½" × 7½ (4cm × 19cm). Punch 2 holes at the top, middle and bottom of each strip, except for the last strips on each side of the cover, which only need 1 hole at the top, middle and bottom. Connect the strips by threading copper wire in and out of each hole.

2 Find the spine of the cover by locating the center piece of bark. Punch 4 holes in the spine in a vertical line: 2 above the center wire holes and 2 below.

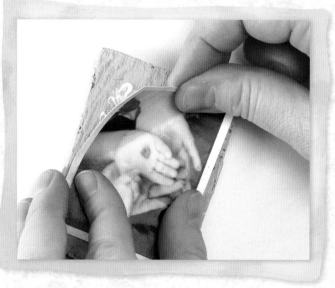

3 Disassemble a small wooden box. Paint 2 pieces of the box with acrylic paint and a foam brush. Hammer two small nails into the side of each piece. These nails will be used to attach the pages to the bark cover.

4 Attach love notes or personal photos printed onto photo paper to each wooden page with craft glue.

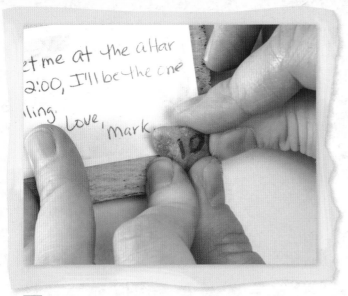

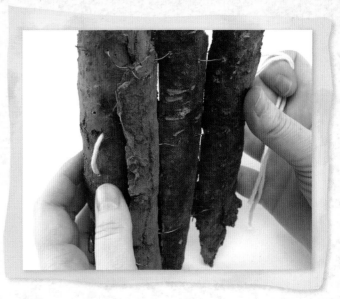

5 Adhere natural findings, such as pebbles or twigs, to the pages with wood glue. I wrote the number 10 on a heart-shaped pebble and glued it to the corner of 1 page.

6 Thread a 30" (76cm) piece of curtain string through the 2 closest center holes from Step 2, pulling both ends through so they are inside the cover.

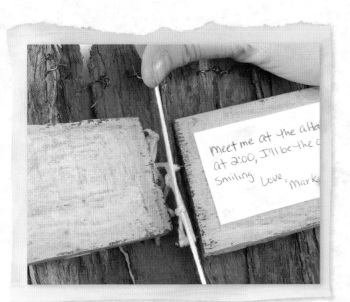

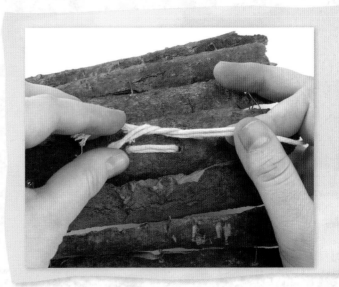

7 Bind the pages together, wrapping the 30" (76cm) piece of string around the nails. Wrap 1 end of the string around the top nail of a page a few times and then double-knot it. Wrap the other end of the string around the bottom nail and double-knot it. Move to the second page and repeat, using the same string. As you wrap, pull the string taut so the pages are snug against the cover.

Thread a 20" (51cm) piece of string through the 2 center holes in the spine, pulling both ends through so they are inside the cover. Wrap the ends of this string around the nails in the second page as before.

8 Thread all string ends through the remaining holes in the spine, bringing them outside the cover. Knot the strings together against the spine to secure them.

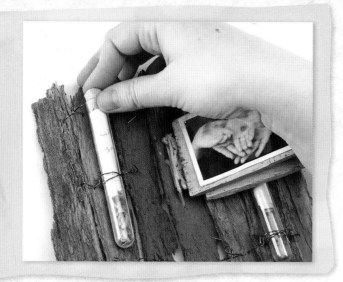

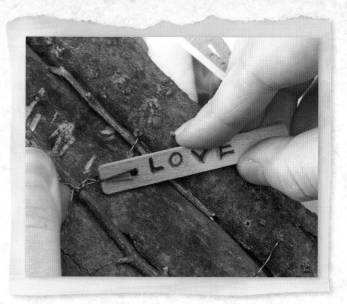

9 Fill 2 plastic vials with messages, love notes or bits of nature and slip them beneath the wires inside the front and back covers.

10 Slip twigs beneath the wires in the front cover. Write a message or the word *love* on a wooden tag and secure it with wire or string to the front cover.

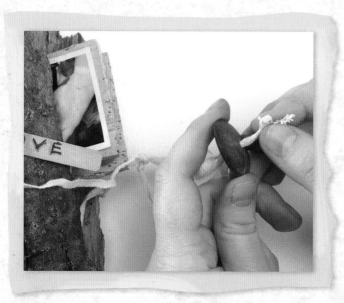

11 Wrap a 12" (30.5cm) piece of curtain string around the outside of the journal. Thread both ends through the hole in a wooden button and tighten the string to keep the journal closed.

inspiring hint

Choose a base that speaks to you. I chose bark for this journal because it appeared to be fragile but was much stronger than it looked. It reminded me of how a marriage can go through troubled times, but when a couple works together, strength is always there.

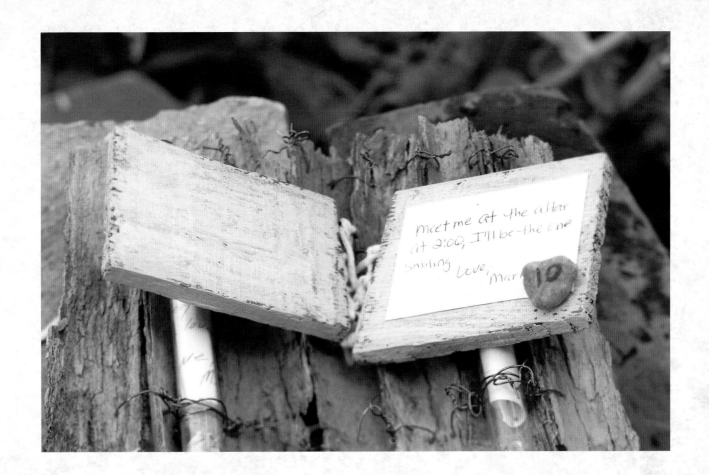

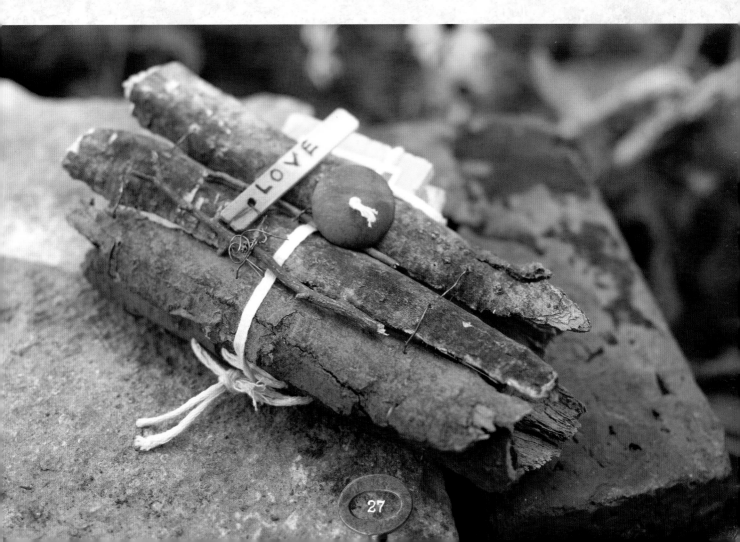

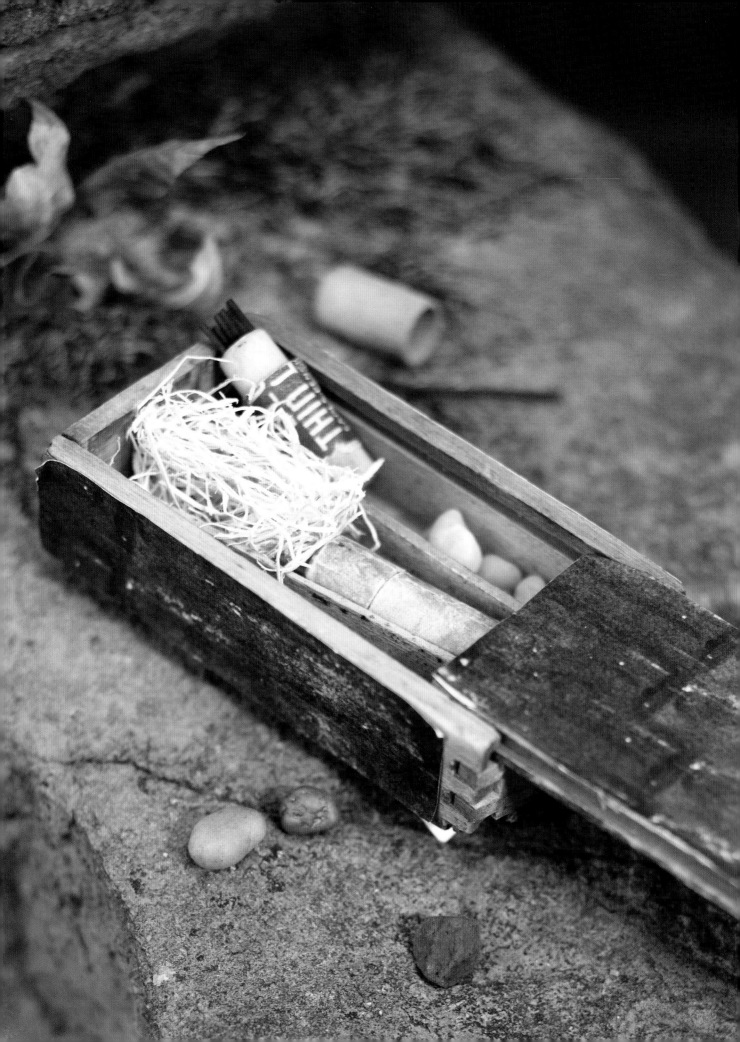

Door Box

It's amazing to find little bottles and boxes that seem as if they were made to go together. When I came across the box in this journaling adventure, it reminded me of a door. I began to imagine hiding some tiny wooden tubes I had discovered at a flea market behind that door. An idea began to form: a perfect little door that led into a personal little world.

{ CAST aSIDE }

The wooden tube containers I placed inside the *Door Box* were originally containers for pencil lead. One tube still contains the original lead! They were discovered at a flea market. Flea markets are great places to search for extraordinary items.

MATERIALS

* pebbles
* printed background with weathered door texture
* soft shredded wood
* tacks
* vintage keyhole
* wooden box with sliding lid
* wooden tube containers

TOOLS

* awl
* craft glue
* scissors

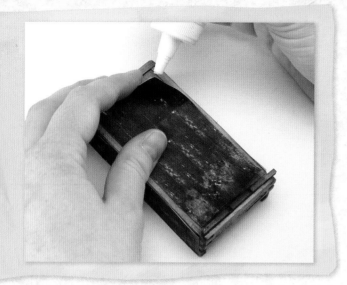

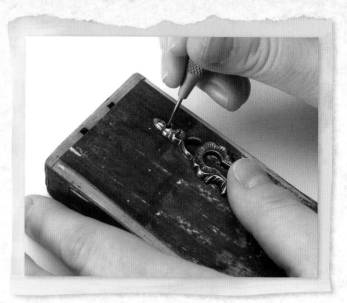

1 Cut a printed background with a weathered door texture into pieces that will fit the sliding lid and all other sides of the box. Attach the papers to the box with craft glue.

2 Determine the placement of a vintage keyhole on the back of the box. Using an awl, poke 2 holes in the wood directly beneath the holes in the keyhole. Attach the keyhole to the box with tacks.

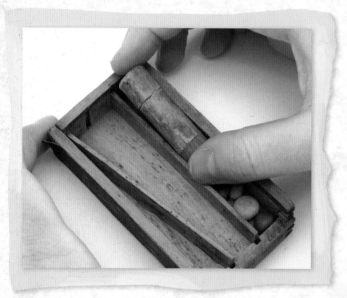

3 Slide the lid from the box. Glue pebbles in a corner and place a wooden tube container inside the box.

inspiring hint

Search for tiny things that are often discarded, or, in some cases, collected, to fill your box.

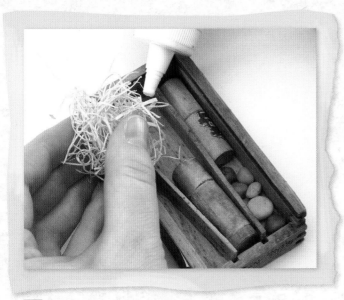

4 Glue soft shredded wood in the empty spaces of the box and place another wooden tube container so that it nestles against the wood. Fill the tubes with beautiful memories and tiny treasures!

inspiring hint

I love the feel of soft shredded wood next to the smoothness of the pebbles. It gives great contrast in textures and mirrors my changing and contrasting moods!

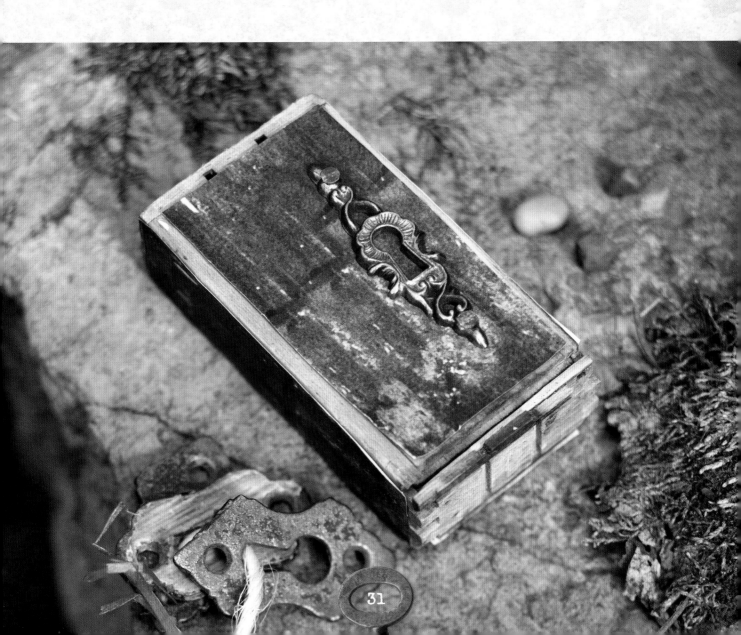

Graven

Geraldine Newfry

The covers of *Graven* were created from two cabinet doors. The headstone-shaped doors provided the inspiration for the journaling. The pages focus on dark images and words of loss. The text block was created from hand-colored paste papers, handmade papers, posters and maps from my collection. The book was bound using the paired-needle Coptic stitch.

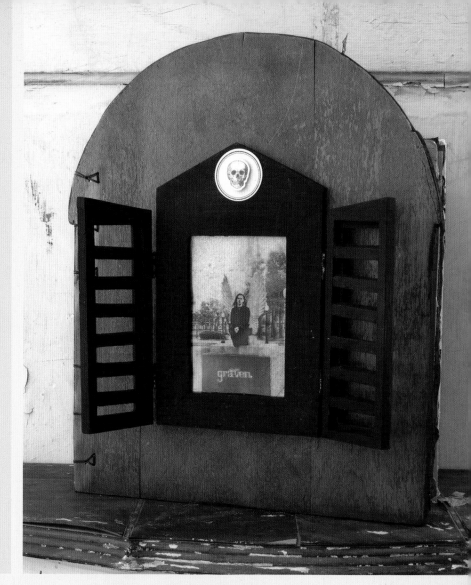

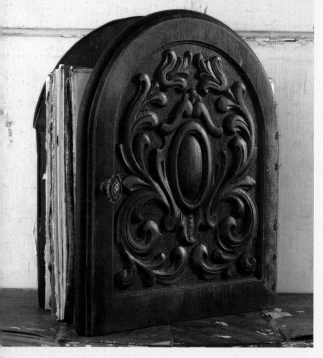

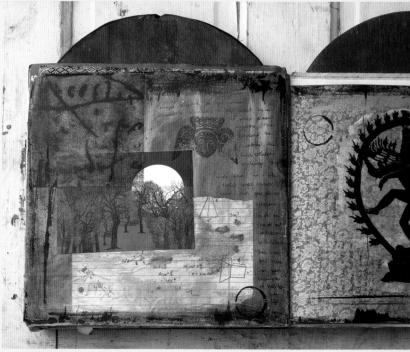

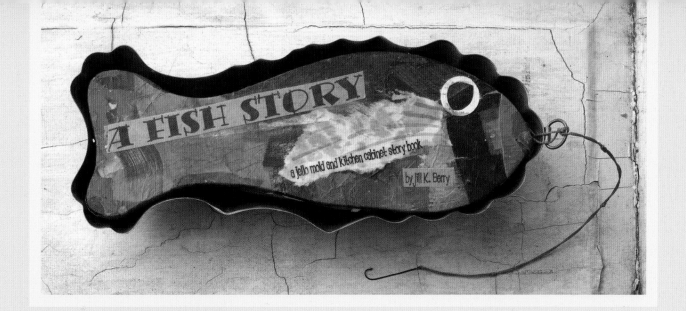

A Fish Story

Jill Berry

This book is made from a gelatin mold and a wooden cabinet door from my kitchen. The pages were covered with painted papers. I wrote the poem for my son, Sam, who loves silly poems. The first two lines were inspired by "Alas, Alack" by Walter de la Mare.

Sam, Sam, come fast as you can,
there's a fish that sings in the frying pan!
The fish that sings lets out a laugh,
and sends a message to the one in the bath.
The fish in the bath starts to scrub-a-dub-dub,
and sends a shout to the one in the tub.
The fish in the washtub leaps up in the air,
and whistles sweet Dixie to the one on the mare.
The fish on the mare starts to gallop away,
and we hear her shouting to the one in the hay.
The fish in the hay wildly dances a jive,
and sends a text message to the one in the hive.
The fish in the hive gets stung by a bee,
and convinces the others to instantly flee.
All the fish gather in a shimmering group,
and fly off into the sunset that glows on our stoop.
The one fish that's left is a rare mannered fellow,
so we let him stay right here in our JELL-O.

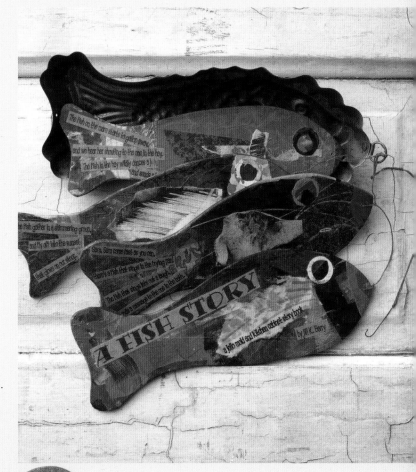

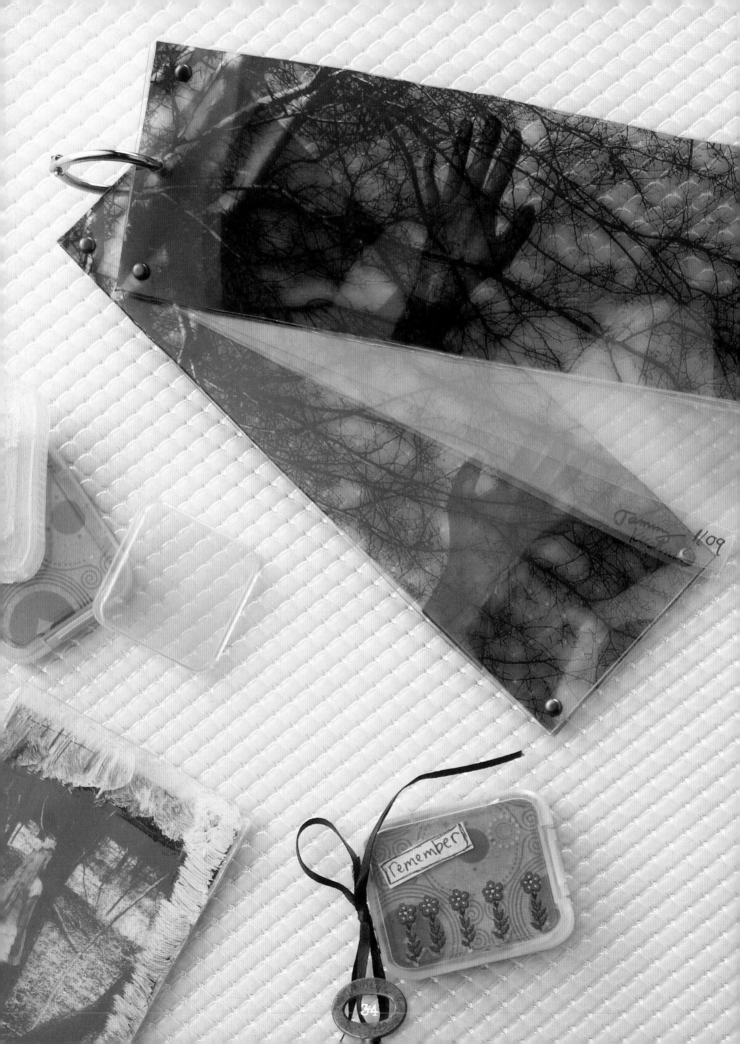

2 *plastic*

Plastic is a material found in nearly everything around us. We find it in our milk cartons and food containers, the chairs we sit on and the cups we drink from. Some of these plastics are sent to recycling centers or bins when we are finished with them, but there are many stragglers that are not. You see them on the sides of roads, washed up on beaches and littered in parks: everything from empty water bottles to six-pack plastic rings. These items are neglected and forgotten while the world moves on.

In these journals, the plastics I use range from transparency paper found in office-supply stores to empty baseball card cases and electronics containers. Take a look around your house, and then another look, when you're searching for your own supplies. Often things look better the second time around.

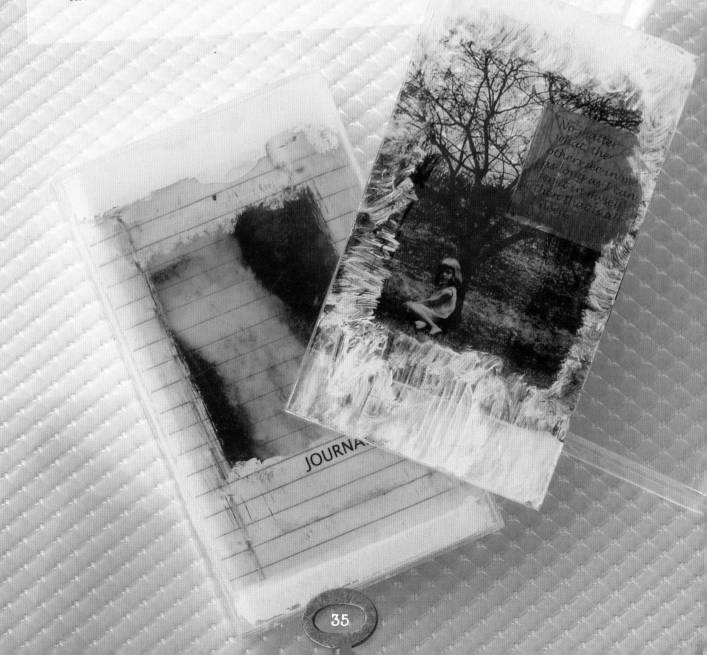

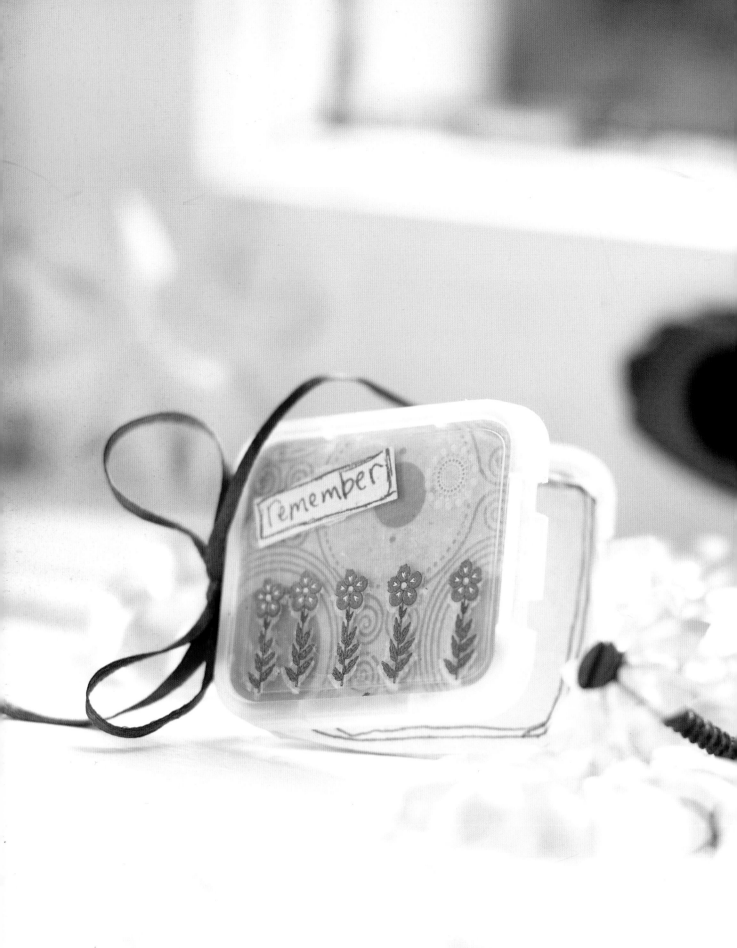

Mini Memory Book

Even though we live in the Digital Age, it's still nice to carry paper and a pencil with you once in a while. It's even better if a book is handmade and can fit anywhere. This book is meant to hold small mementos, as well as cute things the kids may say while you're out and about.

{ CaST aSiDE }

Plastic cases for camera cards or discs come in a variety of sizes. They often snap shut and are sturdy enough to hold images that are scaled down to size.

MATERIALS

* ⅛" (3mm) wide brown silk ribbon
* camera memory-card case
* fine-point permanent marker
* cotton fishing line
* patterned paper
* pencil
* rub-on images

TOOLS

* awl
* craft glue
* scissors

1 Use a camera memory-card case to trace and cut out 2 pieces of patterned paper to fit the inside front and back covers of the journal.

2 Glue the pieces to the inside front and back covers, trimming them if necessary.

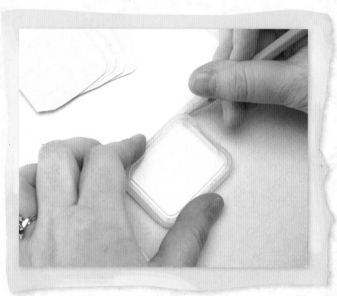

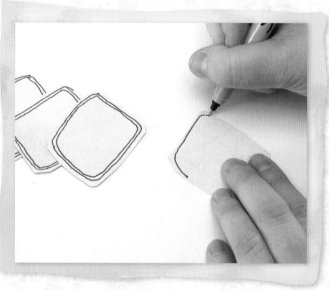

3 Use the case to trace the desired number of pages for the journal from patterned paper, and then cut each of them out.

4 Outline all the pages with a fine-point permanent marker.

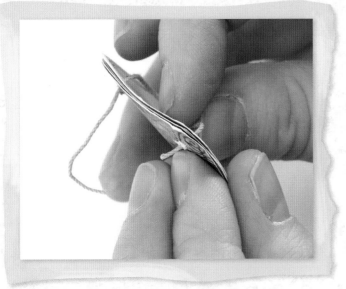

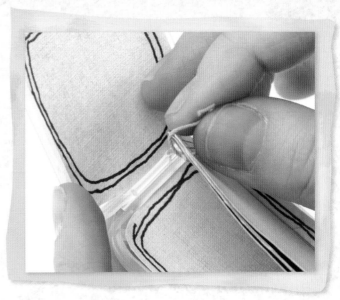

5 Stack the pages and use an awl to poke 2 holes through the shorter left-hand side of each page. Thread the ends of a 4" (10cm) piece of fishing line through each hole.

6 Use the awl to punch 2 holes in the inside seam of the case, where the front meets the back. Thread the ends of the fishing line through the 2 holes in the case to attach the pages to the case. Tie the ends together on the other side of the case.

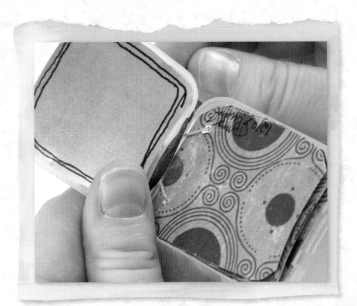

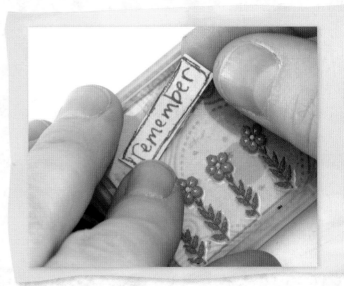

7 Cut a 12" (30.5cm) piece of 1/8" (3mm) wide brown ribbon and center it over the inside seam in the case. Bring the ends around to the outside of the case and tie them into a bow.

8 Apply rub-ons to the front and back of the case. Write the word *remember* on a piece of patterned paper and outline it. Cut out the word and glue it to the front of the case.

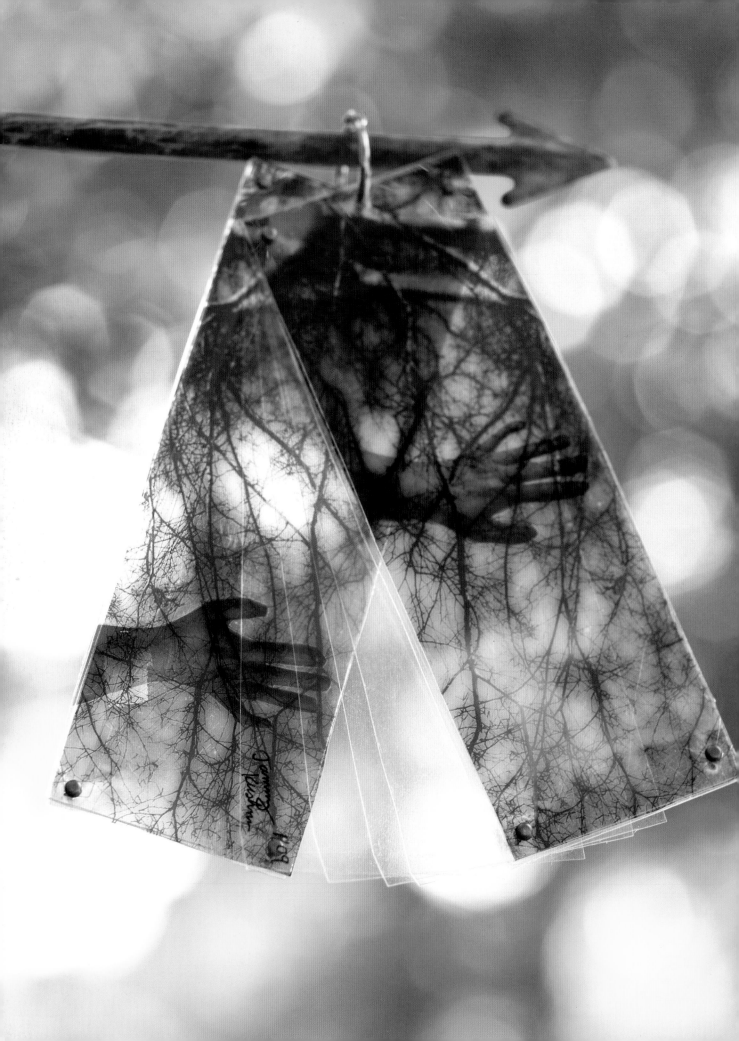

Embrace

I love creating with transparencies. The dimensions that one type of paper can produce are magical and fantastic! The underlying message in this journal is that we all have layers. In this case, some layers may be visible but also require the effort on another's part to look deeper.

MATERIALS

* binder ring
* brads
* hard plastic container
* image of hands
* image of tree branches
* transparency paper

TOOLS

* awl
* clear-drying glue or transparent tape
* ink-jet printer
* scissors

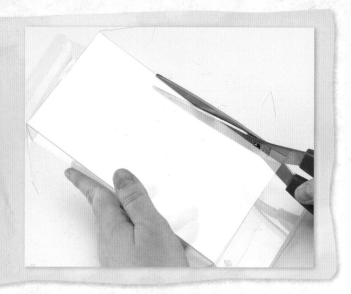

1 Cut 4 pieces from a hard plastic container measuring approximately 5" × 7" (13cm × 18cm).

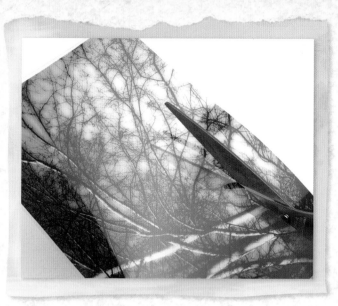

2 Print 2 images of branches onto transparency paper. Trim them to the same size as the plastic container pieces.

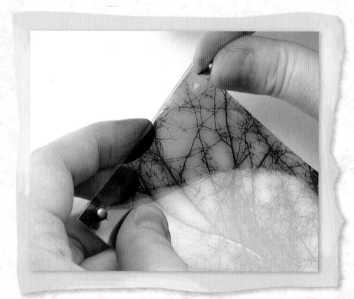

3 Place 2 of the hard plastic slices together and slip a branch image between them. Use an awl to poke a hole in each corner, going through all 3 layers. Fasten brads through 2 holes on 1 shorter side.

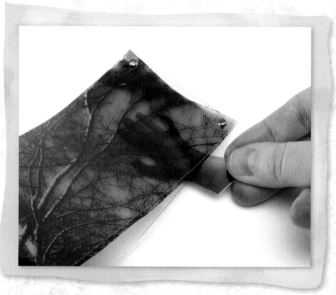

4 Print 2 images of a hand onto transparency paper and trim away the excess. Slip an image of a hand between the branch image and the back plastic slice. Use clear-drying glue or transparent tape to secure the hand image.

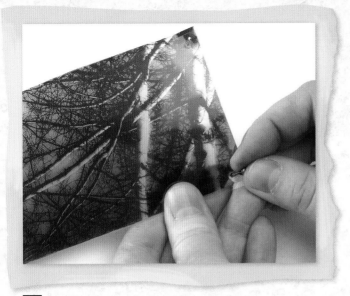

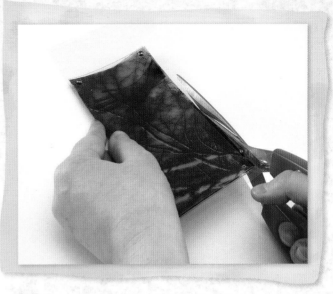

5 Fasten brads through the 2 holes on the other side. Repeat Steps 3–5 for the back cover.

6 For the journal pages, cut the desired number of transparency sheets the same size as the front and back covers. Use a cover as a guide while you cut.

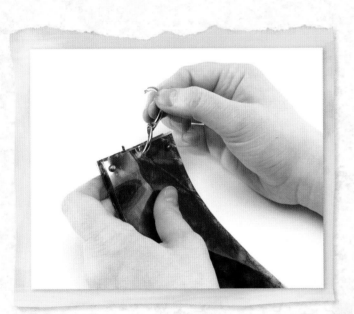

inspiring **hint**

Add your journaling sporadically on the pages so bits and pieces of the words will peek through the branches, encouraging you to unravel bits of yourself at each sitting.

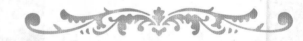

7 Stack the front cover, pages and back cover of the journal. Using an awl, poke a hole in the center of the shorter left-hand side, going through all layers. Slip a binder ring through this hole to keep the book together.

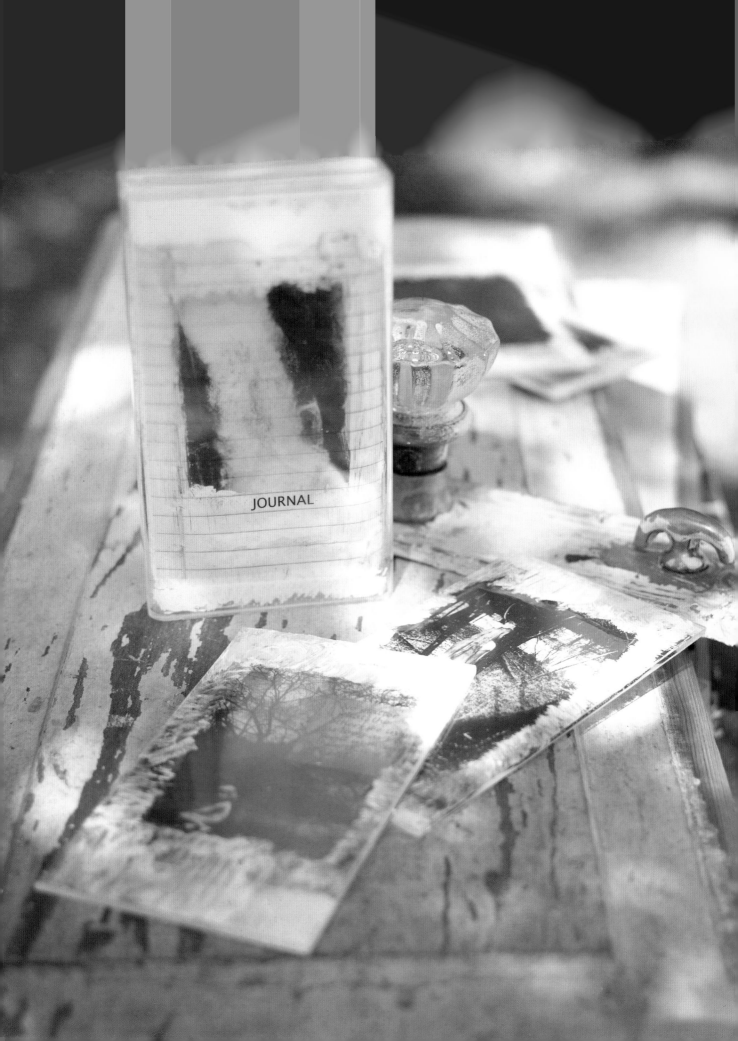

Child Within

Hidden within all of us are the hopes and dreams we often forget or repress as we leave our childhoods and enter "reality." If we look through the pain, problems and abandoned ideas we once had, we can find what we loved and embrace it, follow it and thrive in it. This journal is the link between childhood moments and the present Digital Age of recording it all.

{ CaST aSiDE }

The case used in this journal is the standard packaging for an iPod touch. If you can't track one down, try finding a trading card case used for collecting and storing baseball cards.

MATERIALS

* 24" × 34" (61cm × 86.5cm) acrylic sheet, ½" (13mm) thick

* collage images

* copy paper

* hard plastic case

* personal images

* transparency paper

* white acrylic paint

TOOLS

* acrylic cutting knife

* Adobe Photoshop

* craft glue

* cutting mat

* foam brush

* ink-jet printer

* scissors

* straightedge

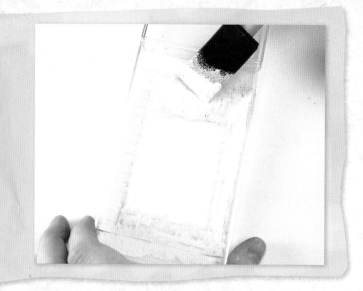

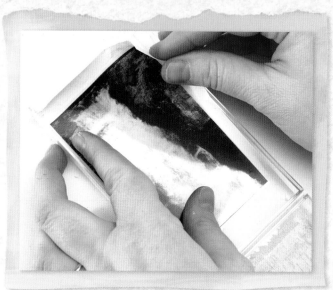

1 With white acrylic paint and a foam brush, generously paint the inside of a hard plastic case. Print an image of vintage lined paper with the word *journal* in the corner onto transparency paper. Once the paint has dried, glue the image to the inside of the front of the case.

2 Print a picture of a waterfall onto a piece of copy paper and glue it inside the back of the case. Once the glue has dried, paint around the edges of the image.

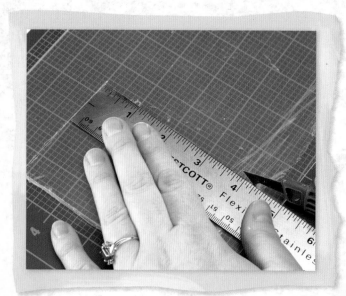

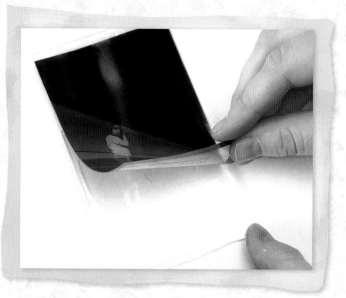

3 Lay a sheet of acrylic on a cutting mat. Using an acrylic cutting knife and a straightedge, score a rectangle in the acrylic that will fit snugly within the hard plastic case. Snap the acrylic along the scored lines to make a rectangular acrylic card. Repeat this step to make 3 more cards.

4 Create an image using Adobe Photoshop, combining personal photos and collage images. Add an appropriate journaling phrase to the page. Print the completed image onto transparency paper. Once the ink has dried (some inks might take 24–48 hours), glue the right side to the back of an acrylic card so the image shows through but cannot be smudged by fingerprints.

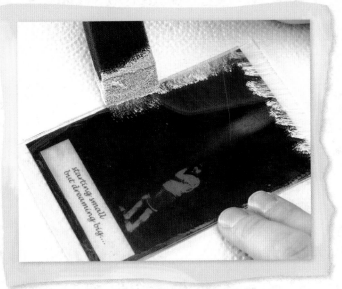 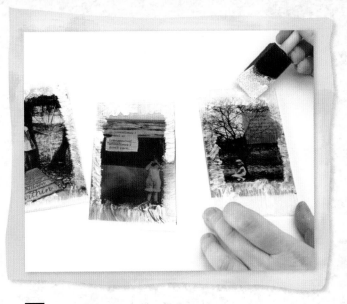

5 Paint the edges and back of the card with white acrylic paint. When painting the back of the card, leave some spaces unpainted for the image on the next card to peek through.

6 Repeat Steps 3–4 for the remaining acrylic cards. Once the cards are dry, stack them face up and place them in the painted plastic case.

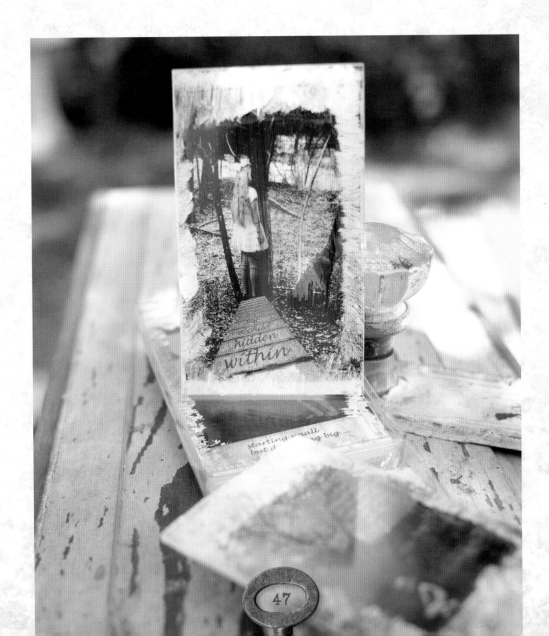

Fractured

Tonia Davenport

The inspiration for this piece came from a poem written during an especially challenging time in my life; a time when I was at the beginning stages of a divorce. *Fractured* is an expression of the fear of expression—the fear of not being understood when we brave sharing what we're feeling; the inner breaking down that occurs from feeling forced to hold so much inside. The cover is Plexiglas, sewn together with nylon beading cord. The spine is secured to the cover with wire rivets and is a piece of Mylar from a Starbucks coffee bag.

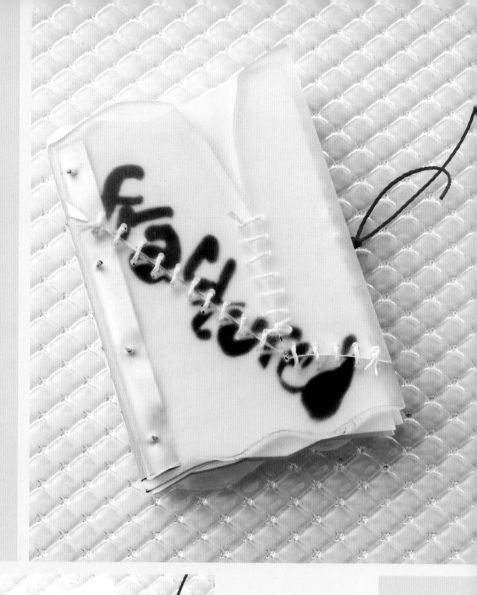

*The lines are
[blank]
for I can't bear to fill in
the words.*

*The words
will drive them away.*

Live the Journey

Kristen Robinson

Journaling has always been such an incredible thing to me. The act of placing written words on paper, or in this case recycled items, as they are experienced is somewhat magical and quite integral to who I am. Whether prompted or completely random, the act of recording where we are and where we intend to go is a journey of it's own. After a lifetime of journaling I find my process has not only evolved but the way I think of journaling has grown as well. The neatly produced lined paper has been replaced by the rogue scrap and repurposed paper.

To make the cover, I placed a large piece of antique ledger paper within a clear used cereal bag and fused it. I fused more bits of cereal bags together to create journal pages; I added strands of thread to some for additional texture. Plastic shopping bags were stacked by the half dozen and fused with an iron; when painted these pages almost resemble a natural fabric much like leather.

To say I found creating this journal delightful would be an understatement. There is an ethereal quality to the pages that calls to me. The ability to experiment and play was more than delightful, and in the end the entire piece is created from upcycled bits that I had right at home.

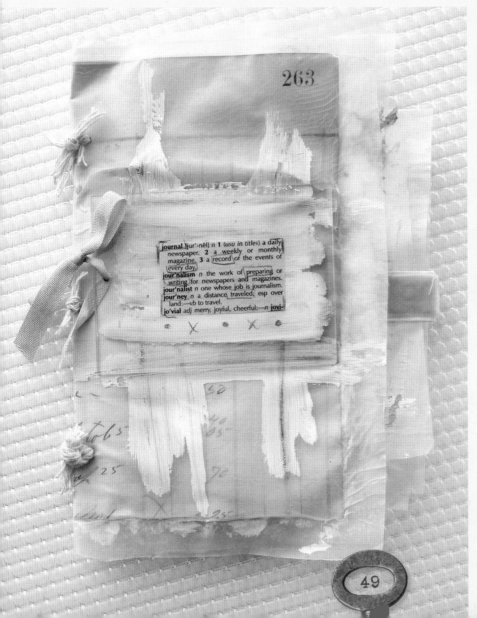

Sweet Swinging Days

Jill Berry

This book is a tribute to the days when I used to take my kids to the park to swing: simple, sweet days. It features Tinkertoys, plastic monkeys from the Barrel of Monkeys game, pages from a vinyl baby book, paper pages stitched inside the book with beads, and a Tinkertoy spine.

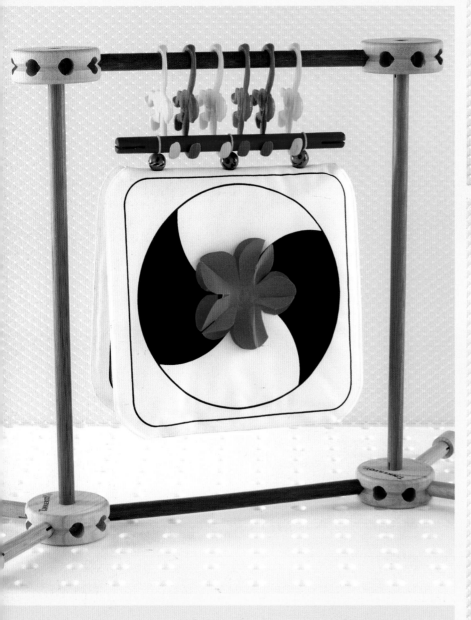

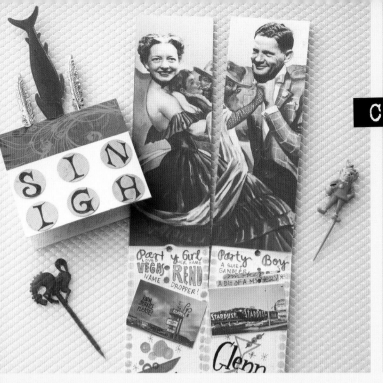

Casino Nights

Jill Berry

This is a group of four journals about my grandparents and their relationship to nightlife places like Las Vegas and Reno. The stir sticks and postcards were theirs.

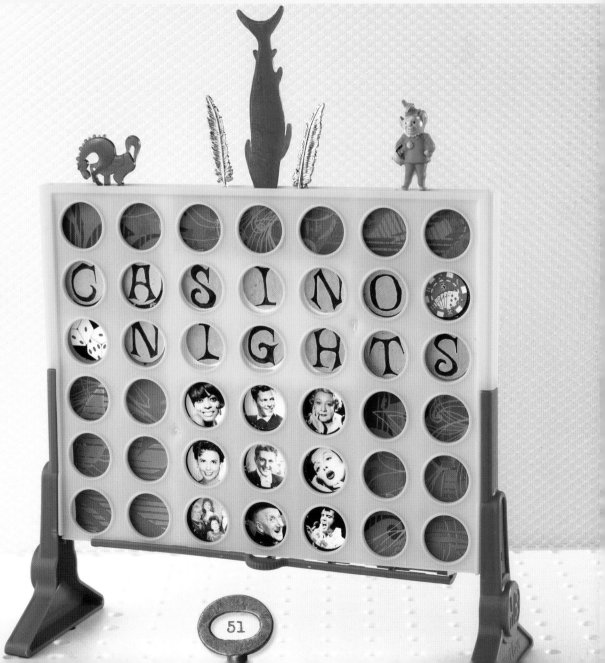

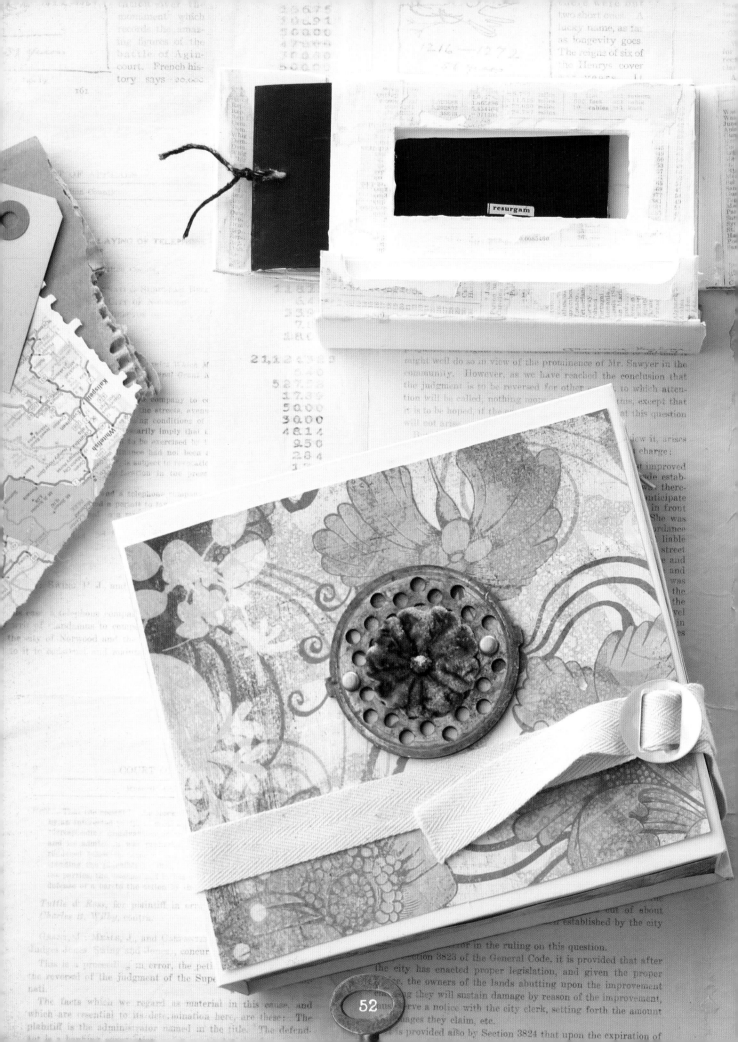

3

paper

Paper comes in many forms: patterned, printed, colored and stark white. When using found papers in a journal, anything will do. Discarded paper packages, shoe boxes, corrugated cardboard and clothing tags can all be turned into a book. While paper is one of the most widely recycled products in the world, plenty of it still ends up in landfills. Consider crafting a journal from paper that didn't make it into the recycling bin. You won't just be expanding your creative side, but you'll also be saving the environment, one scrap of paper at a time.

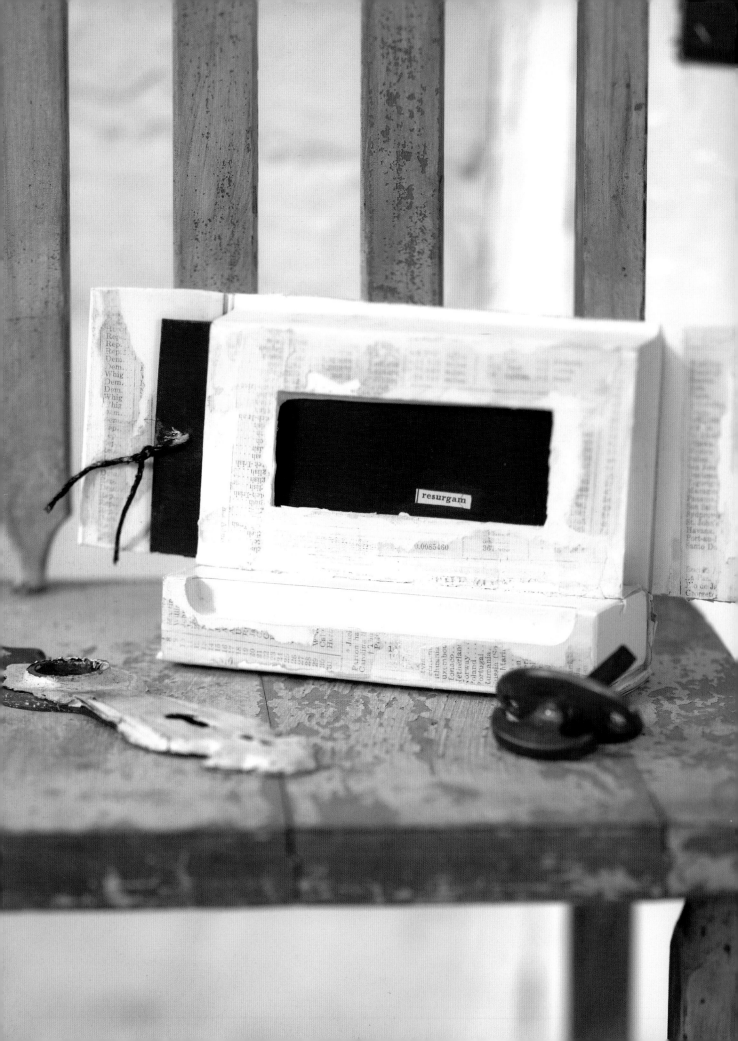

Resurgam

I suffer from obsessive-compulsive disorder. It is a crippling mental disease that causes me to second-guess my actions in everyday circumstances. (For example: Did I just run over someone while I was driving?) OCD comes in many forms and can cause people to fear that they have caused harm to a loved one, or to wash their hands until they bleed, believing they are never clean enough. This journal was created to explore some of the raw emotions I often experience. It is also a statement about resurging and breaking through my setbacks to become stronger and better than when I started.

{ CaST aSiDE }

I have recently become fascinated with clothing tags. They come in all different shapes and sizes. Some have waxy or glossy surfaces, while others are made from recycled paper, giving them a worn look. Still others come in booklets with images galore. Before you discard clothing tags, take a look at their shapes, textures and sizes. Many make great pages for smaller books.

MATERIALS

* cardboard box
* collage images
* fine-point permanent marker
* mark-making tools
* mini booklet from a clothing product
* vintage dictionary pages
* white and black acrylic paints

TOOLS

* craft glue
* foam brush
* sandpaper
* scissors
* utility knife or craft knife

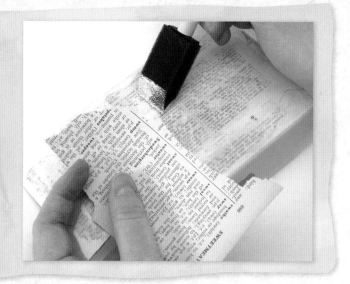

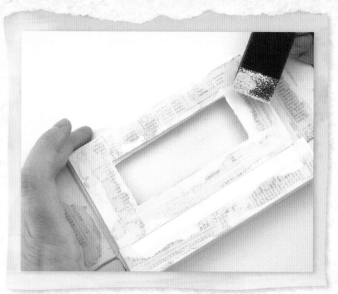

1 Find a small cardboard box that is longer than it is wide. If the exterior of the box is waxy, sand it down before beginning. Using a foam brush and white acrylic paint, paint the box. Before the paint is completely dry, apply torn pieces of vintage dictionary pages to the box. If you find entries for words that hold meaning, add them. If not, be random.

2 Using a utility knife or craft knife, cut a rectangle in the front of the box measuring approximately 3" × 5" (7.5cm × 13cm). Add more white acrylic paint sparingly across the box.

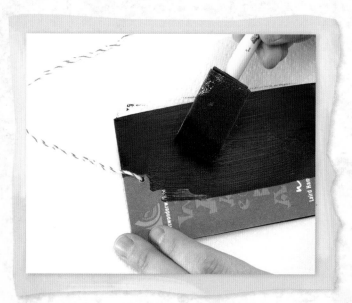

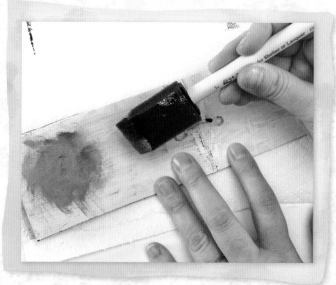

3 Paint the front and back cover of the clothing tag booklet with black acrylic paint.

4 Using a foam brush, paint the inside pages of the booklet with a mixture of white and black acrylic paint. Be sure to dab off the excess paint from the brush so it will appear smudged when it is applied to the pages.

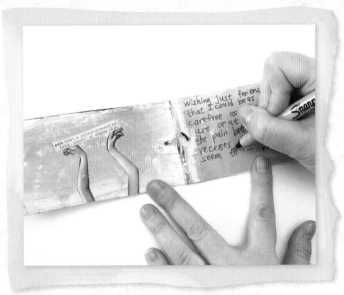

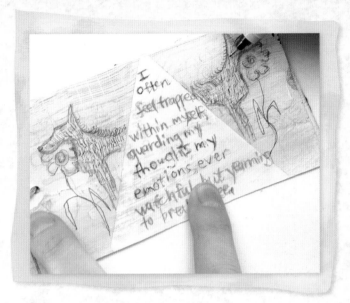

5 After the paint has dried, cut out a public-domain vintage image and a vintage dictionary entry and glue them to one of the pages. On the other pages, journal your thoughts or sketch a design with a fine-point permanent marker.

6 Continue sketching and journaling on the pages. You can use a variety of mark-making tools to express your thoughts. Slide the book into the box so the front cover shows through the "window" in the front of the box.

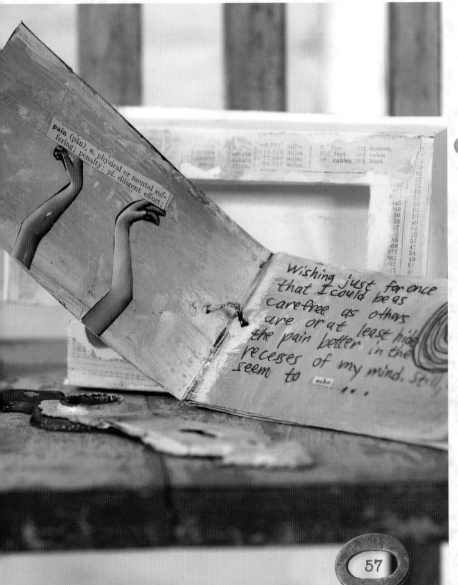

inspiring hint

While not everyone has OCD, we all have fears. Sometimes writing or drawing about our fears can help us overcome them. Find your fear and face it. It is the first step.

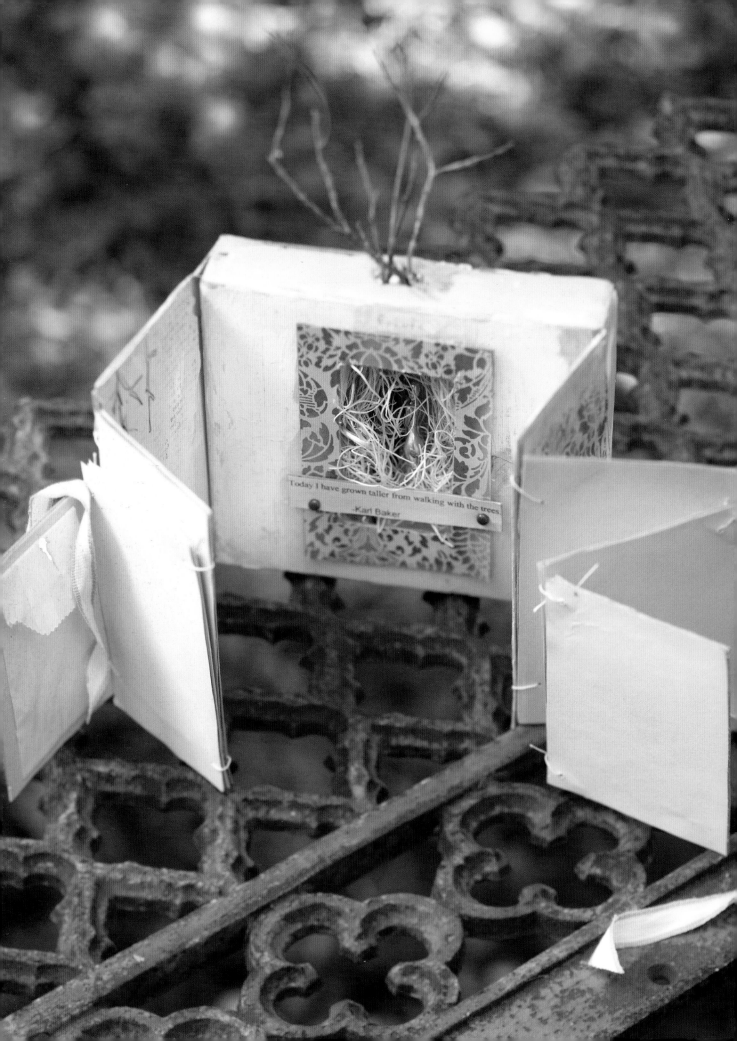

Today I have grown taller from walking with the trees.
-Karl Baker

Nature Journal

While I admit I am not a huge outdoor person, I do love taking walks with my family in our state parks. The sights are breathtaking and cause me to stop and take notice, even for just a quick photo. When I sit back and gaze at the photos I've taken, I realize that they could never do nature justice. While my sketches may not capture it perfectly either, I still think it's necessary and pleasurable to create a piece that defines how I see nature with my own eyes, rather than through a camera lens.

{ CAST aSIDE }

This book was made from a box that came in the mail. Many packages that contained other objects we have ordered have great potential: computer boxes, medicine boxes and much more. Before recycling them, see if you can get inspired by the shapes before you.

MATERIALS

* acrylic paint
* box with deep cavity or opening
* brads
* cardboard
* cloth ribbon or twill
* collage images
* cotton fishing line
* Distress Ink in Tea Dye (Tim Holtz)
* feather
* fine-tip permanent marker
* newsprint paper
* patterned paper
* pencil
* short screws
* soft shredded wood
* twigs
* vellum envelope
* vintage dictionary pages
* vintage images

TOOLS

* awl
* craft glue
* craft knife
* cutting mat
* foam brush
* rectangle stencil template (optional)
* sandpaper (optional)
* scissors
* sponge for applying ink
* straightedge

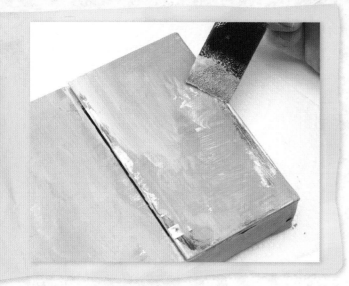

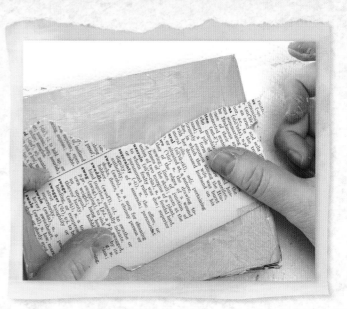

1 Find a box that opens up like a cupboard or create one by slicing a slit down the center using a craft knife. The box should also have a deep cavity within it. If the box is waxy, sand it down. Paint the entire box with your choice of acrylics.

2 Apply torn vintage dictionary pages to the still-wet paint, but don't cover the front flaps of the box. Apply more paint to cover small areas of the pages. Let the paint dry.

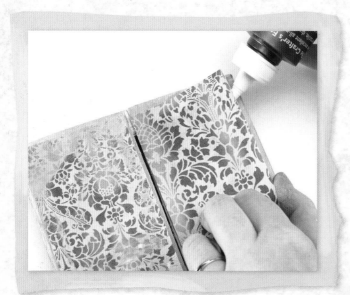

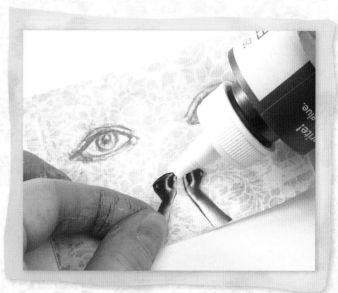

3 Print and cut rectangles from a collage background image or use patterned paper to fit on the front flaps of the box. Glue the rectangles to the flaps. Paint a bit around the edges to "grunge" them up.

4 Design a mini-collage to fit on the back of the box. I sketched eyes and collaged 2 hand images and a feather onto my mini-collage, but you can do whatever you like.

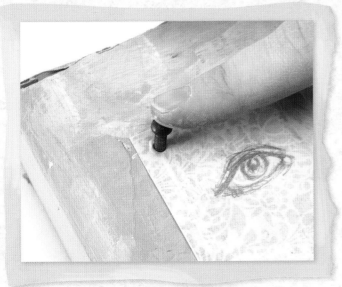

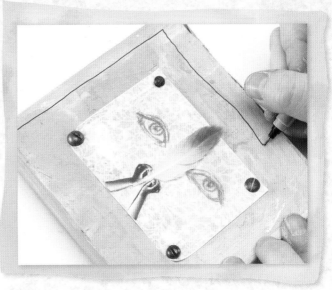

5 Using an awl, poke holes in each corner of the collage. Place the collage on the back of the box and apply a dab of craft glue in each of the holes. Push short screws through the holes in the collage, punching through the back of the box.

6 Sketch lines along the edges of the back of the box with a fine-tip permanent marker.

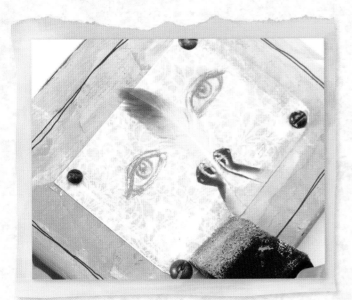

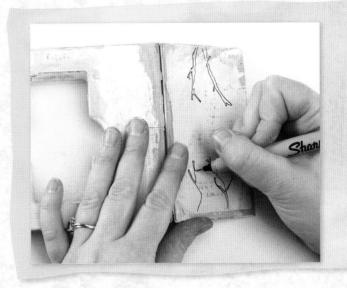

7 Dab acrylic paint around the edges of the collaged image.

8 Open up the front flaps of the box. Sketch tree branches onto the inner flaps of the box with a fine-tip permanent marker.

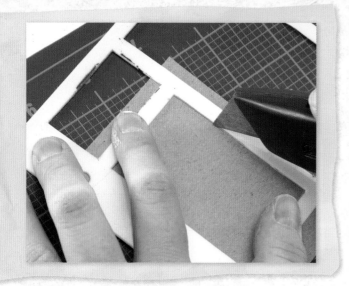

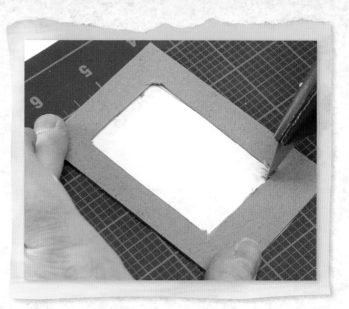

9 Cut a rectangle that is slightly larger than the cavity in the box. You may wish to use a rectangle stencil template. Using a craft knife, cut out the center of the rectangle to create a frame.

10 Glue a piece of scrapbooking paper to the frame. Flip the frame over and cut away the excess paper in the center of the frame with a craft knife.

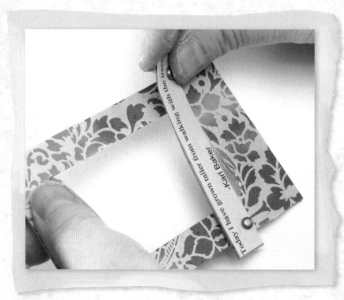

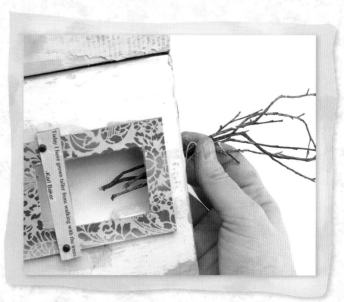

11 Print a quote onto newsprint paper and cut it out. Glue the quote to a piece of cardboard and then cut it out again. Ink the edges with Distress Ink. Attach the quote to the cardboard frame with brads. Glue the frame to the box, along the edges of the box cavity.

12 Using the awl, make a hole in the top of the box, above the cavity, large enough for a bundle of twigs to fit through. Tie a bundle of twigs together with fishing line. Slide the twigs through the hole.

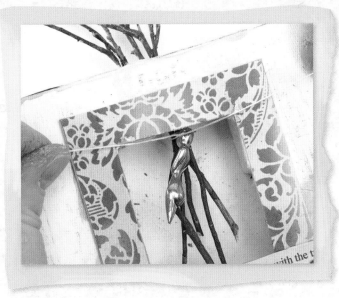

13 Using a separate piece of fishing line, tie a woman charm to the bundle of twigs so it nestles within the frame.

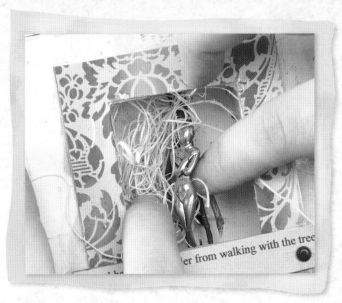

14 Tuck a bit of soft shredded wood inside the frame.

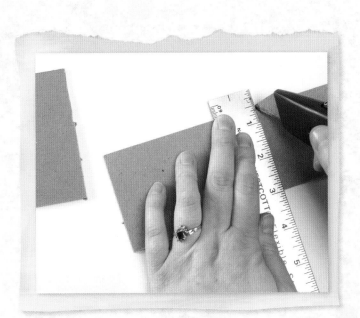

15 Cut 3 cardboard pages to fit the inside flaps of the box. Their widths should match the width of the flaps, and their heights should differ by approximately ½" (13mm) increments. The rectangles I cut measured 2½" × 3½" (6.5cm × 9cm), 2½" × 3" (6.5cm × 7.5cm) and 2½" × 2½" (6.5cm × 6.5cm).

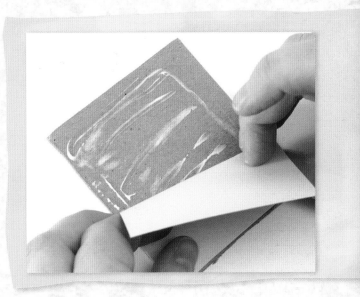

16 Glue pieces of newsprint paper to cover both sides of each cardboard page.

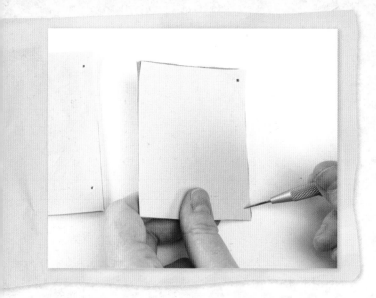

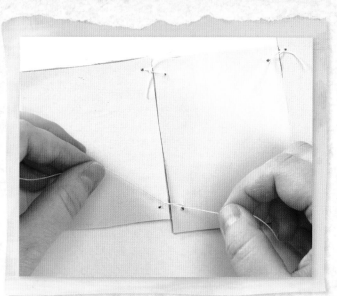

17 For the largest and second-largest pages, use an awl to make a hole in all 4 corners. For the smallest page, make holes in the corners along the right-hand side.

18 Arrange the pages from smallest to largest. Connect them by threading fishing line through the holes and tying double knots. The pages should fold back and forth like an accordion. Repeat Steps 15–18 to create a second set of pages.

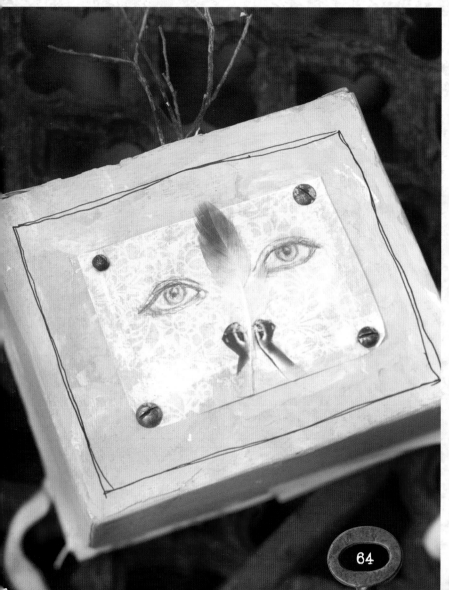

inspiring hint

When creating a journal, choose a topic that interests you. I wanted to create a simple book that would remind me of my natural surroundings. Use this project as a starting point to create an art-themed journal in which you can sketch or doodle what you see around you.

19 Poke holes in each of the outer corners of the box flaps. Using fishing line, tie a set of pages to each flap so that the smallest pages are farthest from the center. Glue a vellum envelope to the smallest page on 1 of the page sets.

20 Close the box flaps. Cut a piece of cloth ribbon or twill that will wrap around the box completely, with some excess left over. Secure the flaps by tying the ribbon around the box in a loose bow.

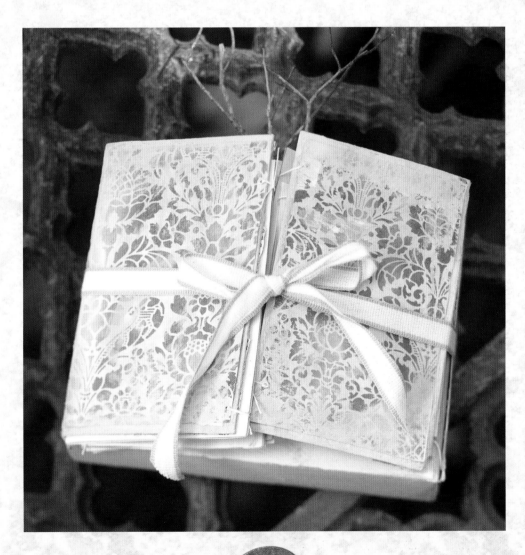

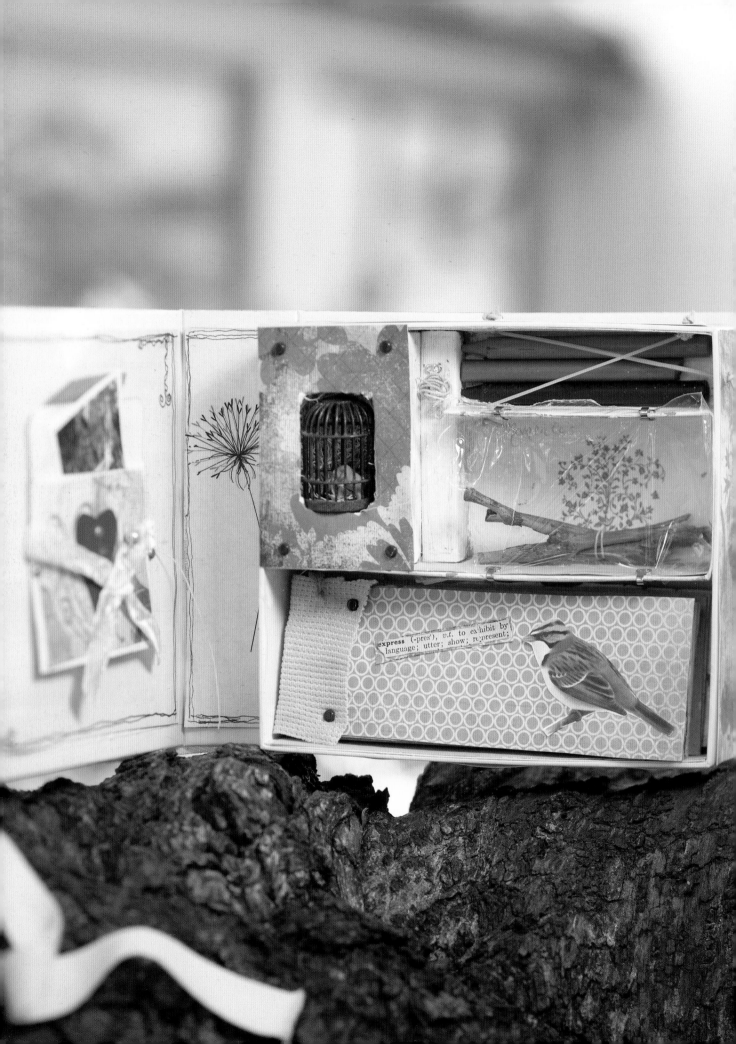

express (-pres'), *v.t.* to exhibit by language; utter; show; represent;

Stationery Set

When I came across this box, I couldn't wait to work with it! There were so many little compartments that were perfect for storing odds and ends. As I began to put it together, the idea dawned on me to make it into a stationery set that included a small journal. This project coincides with my love of drawing and also gives me a place to write.

{ CaST aSiDE }

As you may have realized, I adore boxes. Over the years I have seen and purchased many types of boxes, made from a variety of materials. It took me a while, but over time I got a feel for them and could imagine a finished journal before it had even begun. This box once held soaps and other small spa items. The dividers were what drew me toward it.

MATERIALS

* box with compartments or "shelves"
* brads
* burlap cloth
* cellophane
* corrugated and noncorrugated cardboard
* cotton fishing line
* crayons
* cut rubber bands
* Distress Ink in Tea Dye (Tim Holtz)
* fabric flower
* fine-tip permanent marker
* heart embellishment
* image of a bird
* library pocket envelope
* metal charm
* metal findings (vintage safety pins, metal buttons, etc.)
* metal piece from a meat grinder
* miniature birdcage

* miniature plastic elephant
* patterned paper
* pearl-headed straight pin
* personal and vintage photos
* plastic buckle
* rub-ons
* small brown envelope
* soft shredded wood
* tiny metal clips
* twigs
* twill tape
* velvet and silk ribbon
* vintage dictionary pages

TOOLS

* awl
* craft glue
* craft knife
* rectangle stencil template
* scissors
* sponge for applying ink

1 Cut a piece of patterned paper to fit the front of the box and adhere it in place with craft glue. Repeat this step for the back of the box.

2 Cut pieces of patterned paper to fit all sides of the box and adhere them in place with craft glue.

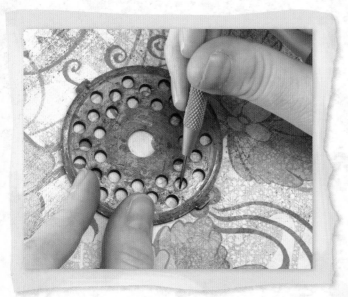

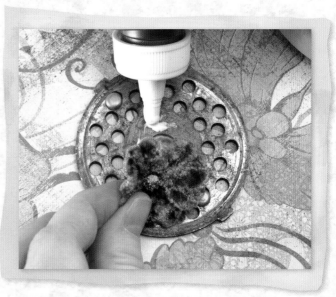

3 Center a metal meat grinder piece on the front of the box. Using an awl, pierce the box through holes in the meat grinder piece, making a hole on the left side and a hole on the right side. Attach the piece through the holes in the box with brads.

4 Glue a fabric flower to the center of the meat grinder piece.

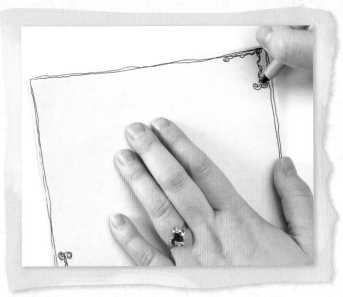

5 Cut a piece of patterned paper to fit the inside lid of the box, but do not glue it in. Doodle around the edges with a fine-tip permanent marker.

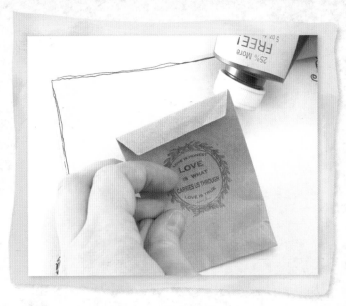

6 Apply a rub-on transfer to a small brown envelope. Glue the envelope to the center of the patterned paper.

7 Apply Distress Ink to the edges of a library pocket envelope with a sponge.

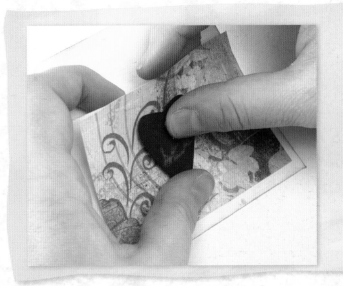

8 Cut a piece of patterned paper to fit over the library pocket envelope. Apply a rub-on transfer to a heart embellishment. Attach the heart to the patterned paper, and then glue the paper to the center of the envelope. Push a brad through both the heart and the front of the pocket.

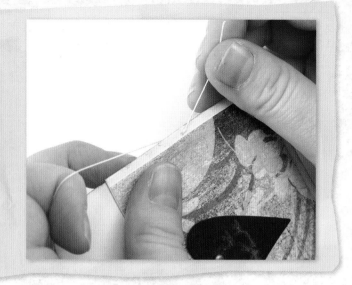

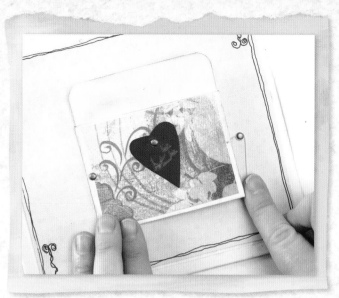

9 Make a hole in the right side of the pocket envelope and thread a piece of fishing line through it.

10 Attach the envelope to the patterned paper with a brad on the left side. Fasten a brad to the right of the envelope, parallel to the fishing line. Wrap the fishing line around this brad to secure it in place. If desired, swing the envelope up and glue hidden photos or notes beneath it. Glue the pocket envelope to the inside of the box's lid.

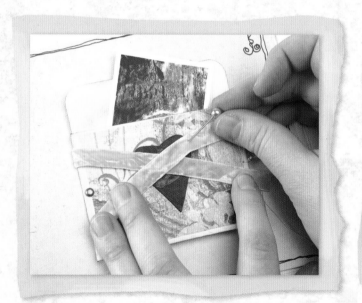

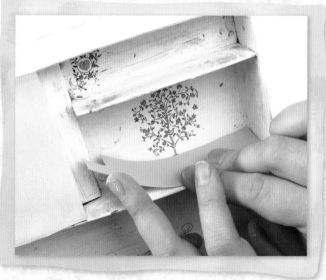

11 Embellish the envelope with a piece of ribbon and a pearl-headed straight pin. Tuck a small picture or note into the pocket.

12 Paint the inside of the box. Once the paint has dried, apply rub-on embellishments as desired. Cut strips of patterned paper to line the "shelves" of the box and glue them into place.

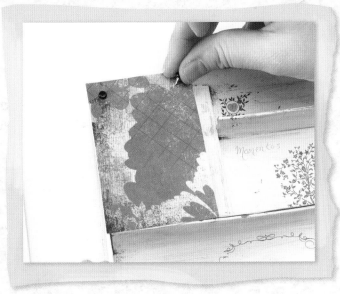

13 If your box has a raised, hollow section, cut a piece of patterned paper to fit over it. With the awl, poke a hole in each corner of the raised section and then push a brad through each hole.

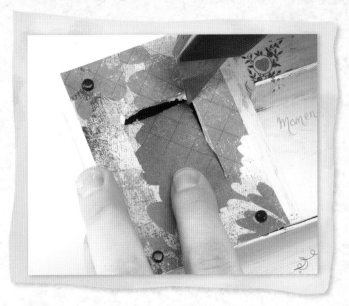

14 Use a rectangle stencil template to cut out the center of the raised section, making a frame.

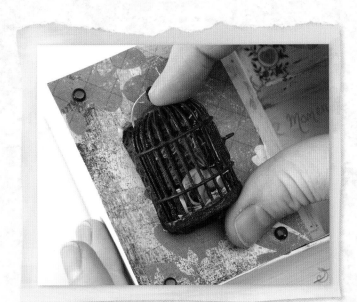

15 Nestle a bit of soft shredded wood in the frame opening. Glue a miniature plastic elephant inside a miniature birdcage and place the cage inside the opening.

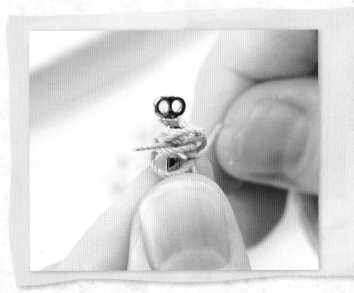

16 Tie fishing line to a tiny metal clip and wrap it around the clip. Glue the clip to a "shelf" in the box. You can attach findings or trinkets to the other end of the fishing line as you find them.

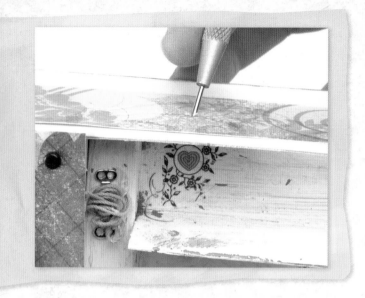

17 Use the awl to poke 2 holes in the top of the box, above 1 of the shelves. Poke 2 holes directly below these holes, in the actual shelf.

18 Thread pieces of rubber bands in a crisscross pattern through the holes. Place crayons behind the rubber bands.

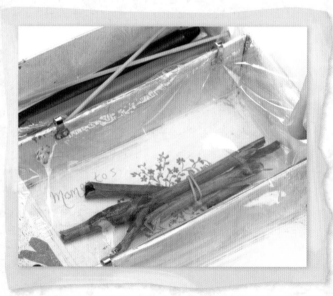

19 Tie a bundle of twigs and place them on one of the shelves. Cover the shelf with a piece of cellophane and attach the cellophane to the shelf with tiny metal clips.

20 Punch holes in other shelf sections with an awl. Add metal findings such as vintage safety pins or metal buttons by attaching them to the box with brads. If you attach findings to the largest shelf section of the box, they should be relatively flat to accommodate a book.

21 Cut a strip of patterned paper to fit the section between the inner lid and the inside of the box. Adhere the patterned paper to this section with craft glue. Draw and doodle on this strip with a fine-tip permanent marker.

22 Construct the book. Cut several pages from thin noncorrugated cardboard that will fit inside the largest shelf section of the box. Cut slightly thicker, pieces of corrugated cardboard for the front and back covers. Glue pieces of patterned paper to the front and back covers. Using an awl, poke a hole in the top left and bottom left corners of the book. Make sure the awl goes through all of the cardboard pages and the covers. Thread a piece of fishing line through each hole and tie a double knot.

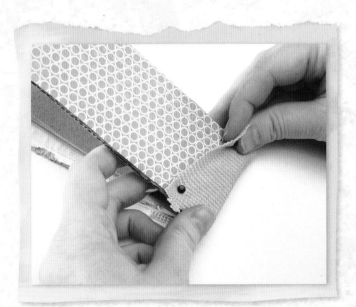

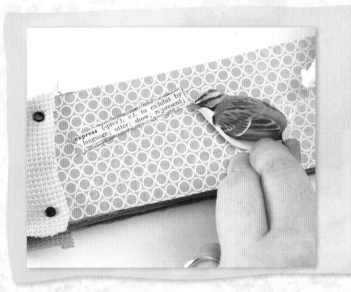

23 Attach a piece of burlap cloth around the binding of the book, fastening it to the edges of each cover with brads.

24 Cut out a definition from a vintage dictionary page and an image of a bird. Glue both to the front cover.

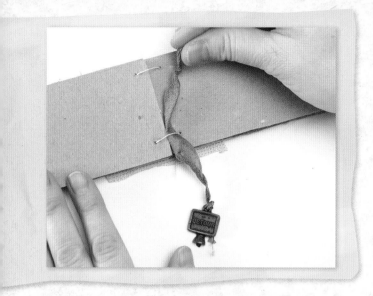 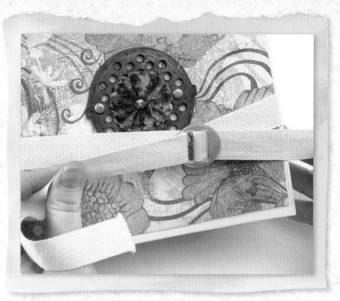

25 Slip a ribbon with a charm attached to one end through the fishing line binding in the book to use as a bookmark.

26 Close the box. Cut a piece of twill tape that will wrap around the entire box with some excess on each end. Secure the twill tape ends with a plastic buckle.

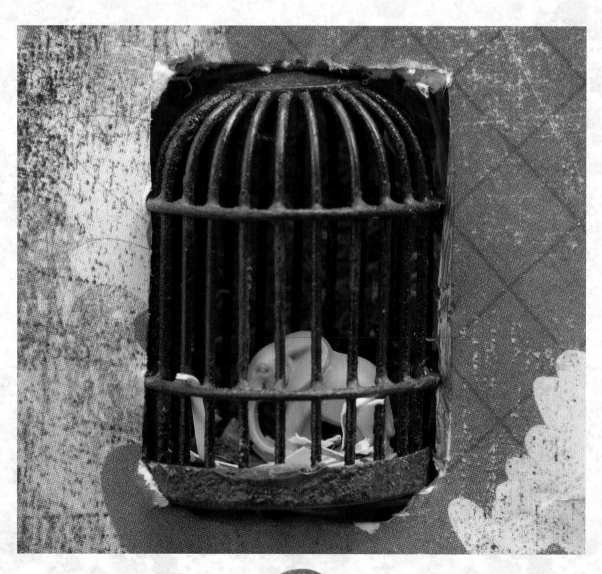

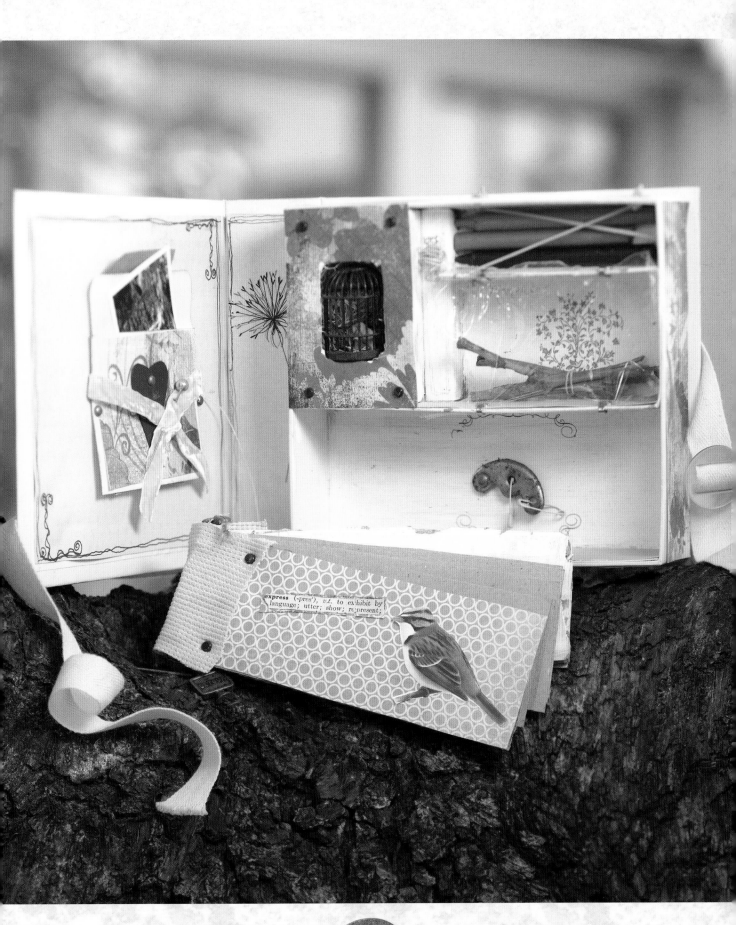

Bean Girl Fortunes

Sarah Fishburn

I'm the spunky sort of woman who doesn't always carry a purse, so it's not likely you'll ever find me with a big fat journal, or all the requisite accoutrements for "brilliant art journaling anytime, anywhere." *Bean Girl Fortunes* is a repurposed pocket notebook that actually fits in one's pocket. I pre-collaged ragtag items and scraps from catalogs and odd bits of wrapping paper onto the pages, then added a dash of metallic paint for pizzazz throughout. I carry this journal and a glue stick whenever we eat at a Chinese restaurant. When we get our fortunes after dinner, I can just stick mine in, then and there. Immediate gratification + instant art = true good fortune!

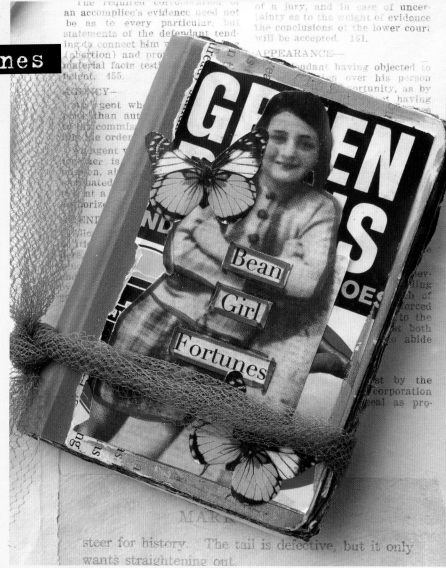

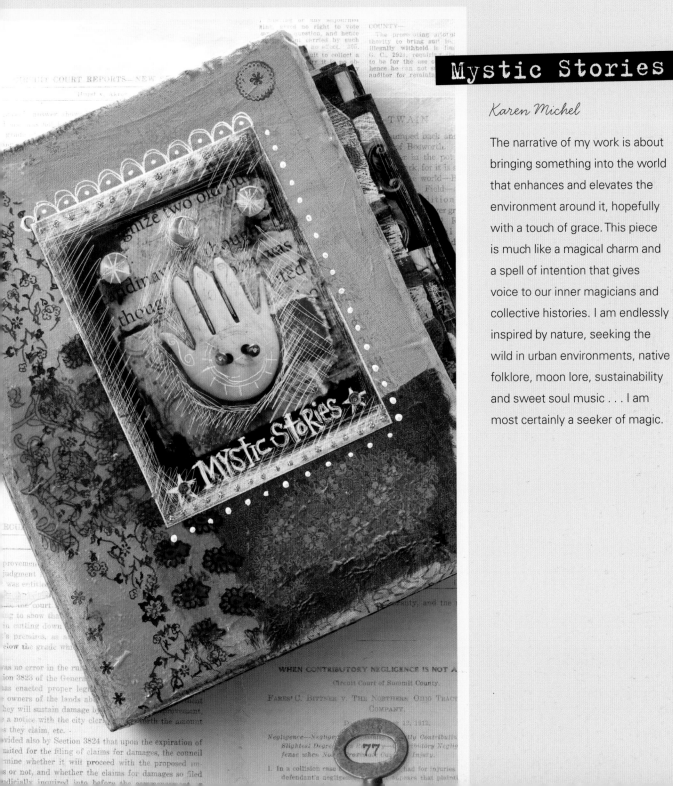

Mystic Stories

Karen Michel

The narrative of my work is about bringing something into the world that enhances and elevates the environment around it, hopefully with a touch of grace. This piece is much like a magical charm and a spell of intention that gives voice to our inner magicians and collective histories. I am endlessly inspired by nature, seeking the wild in urban environments, native folklore, moon lore, sustainability and sweet soul music . . . I am most certainly a seeker of magic.

Polaroid Journal

Susan Tuttle

I learned the art of bargain hunting from my mother, and I have taken it to a whole new level in my art. I frequent our town dump for art loot—rusty salvage, discarded aging notebooks, old photos, vintage ribbon, bindings, chipped teacups and more. There is something I find thrilling in saving these discarded items from destruction and reinventing them in my work, plus there is the added bonus of "going green" in recycling these finds. I have a love of Polaroids—that yellowed, vintage look of yesteryear really speaks to me. This Polaroid journal is a natural outpouring of the artistic elements that I am passionate about.

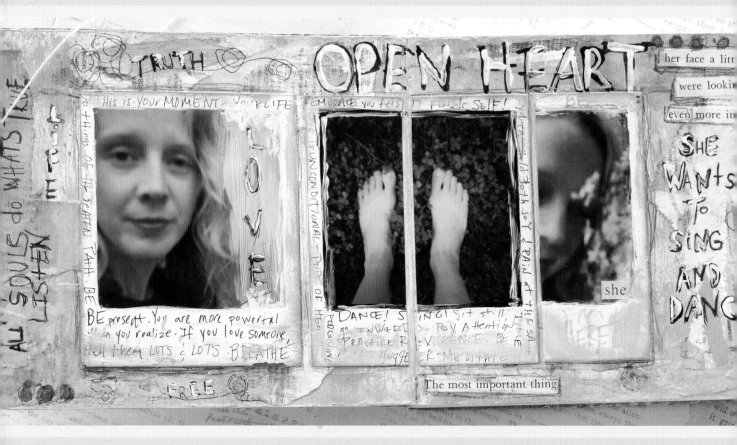

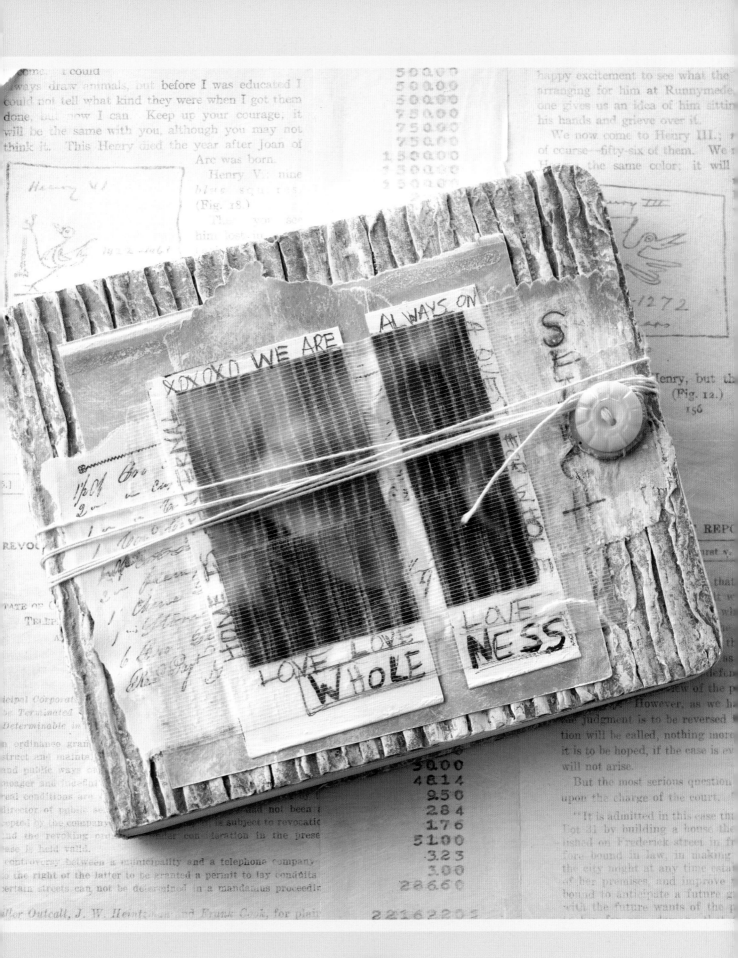

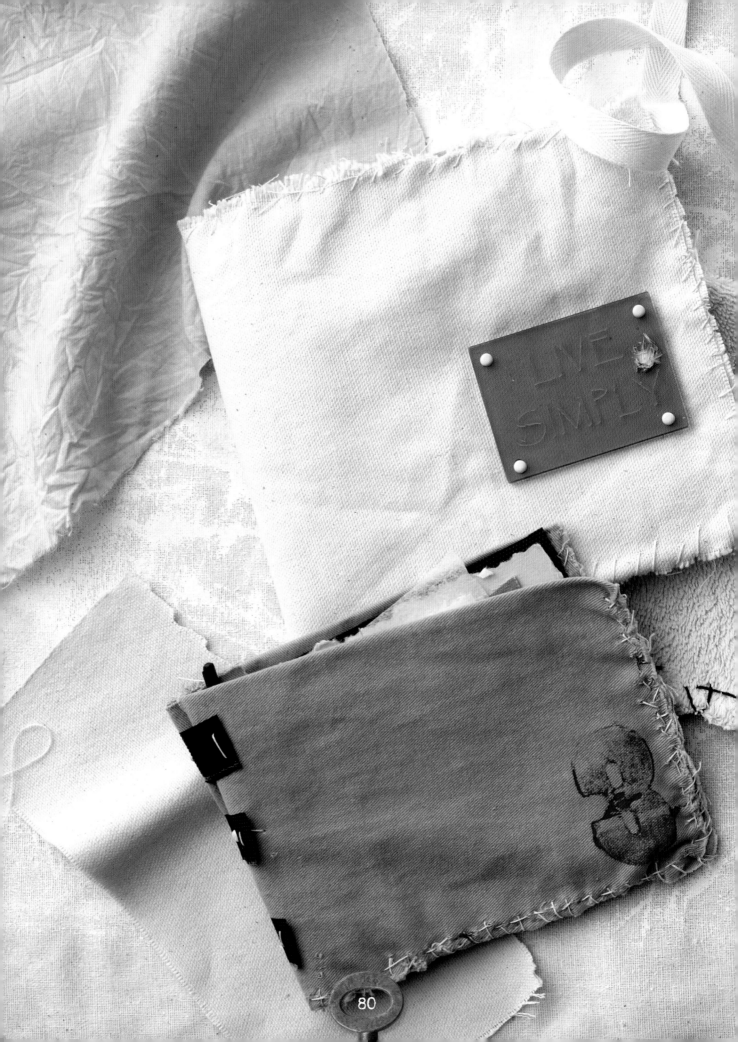

4 fabric

We rely on fabric to clothe us and help us clean, to keep us warm at night and make our homes more cozy. We use dish towels, jeans, T-shirts, sheets and blankets in our everyday lives. In the past, when socks had holes in the heels, they were darned. Jeans were patched and life went on. But today, we often discard clothes that have rips or tears rather than repair them or find another use for them. I used to do it myself. More recently, though, I realized that even if I can't darn socks or patch jeans, that's okay. I can do something even better with them: I can make art.

Finger prints only tell so much....

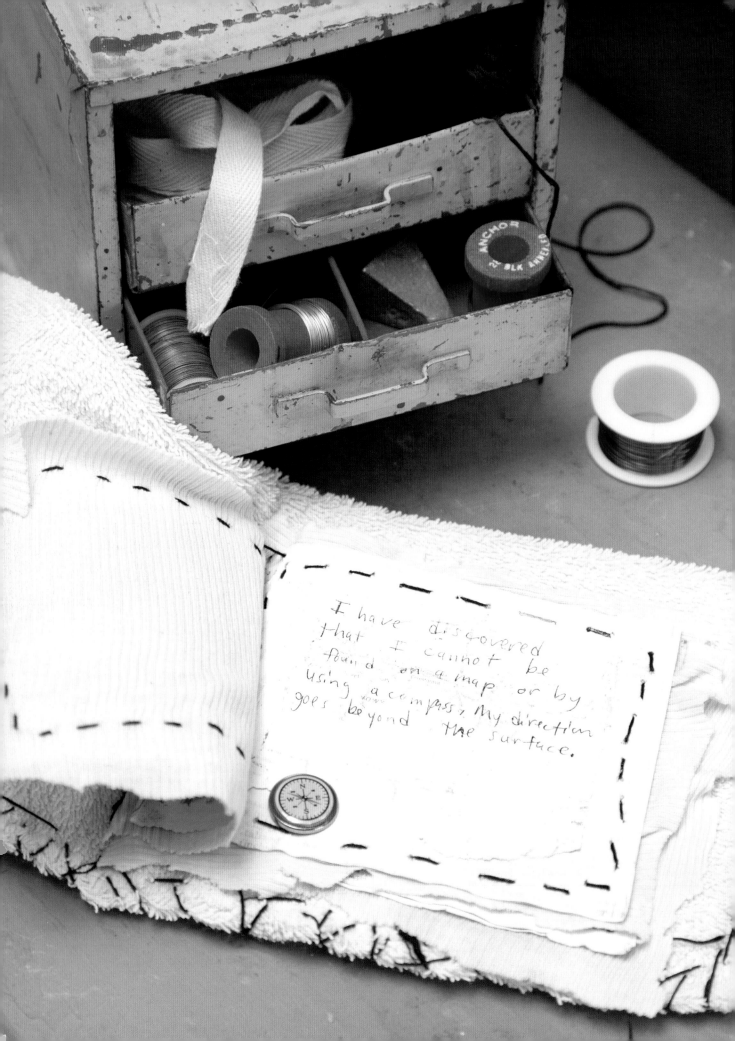

Finding Me

We all have a need to discover who we are. While this task might seem like a natural process, it is often one that takes the most effort. We can get lost in the ideals of others and misplace our own. This journal exists to encourage you to look within, piece by piece, to find yourself.

{ CaST aSiDE }

I had the same bath towels for over 10 years. When the time came to donate them, some were not in the best shape. I hated to throw them out, so instead I decided to use them as the pages and cover for a journal. They are fluffy and don't need any extra batting, which saves both money and the environment at the same time.

MATERIALS

* black ink
* brads
* collage images
* crochet thread
* fine-tip markers
* map portion
* newspaper
* old T-shirt
* thin, flat piece of rubber
* transparency paper
* vintage camera cover
* white acrylic paint
* worn bath towel

TOOLS

* craft glue
* foam brush
* scissors
* sewing needle

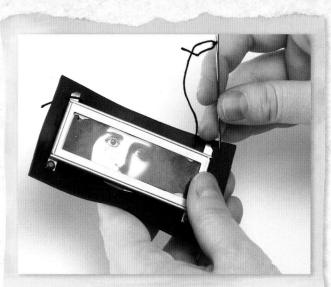

1 Cut a worn bath towel into a rectangle measuring 12" × 14" (30.5cm × 35.5cm). Fold it in half widthwise, and then again in half widthwise. This will serve as the front and back cover of the journal.

2 Print a collage image onto transparency paper. Cut it to fit behind a vintage camera cover. Attach the camera cover to a slightly larger piece of thin, flat rubber with brads. The camera cover I used didn't have holes in the top, so I stitched the top to the rubber using crochet cotton thread and a sewing needle.

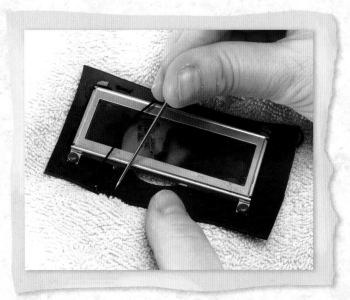

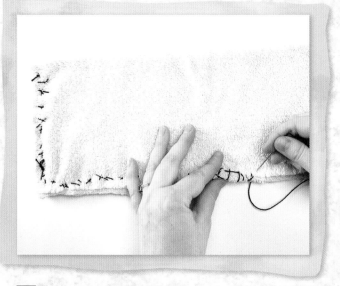

3 Stitch the rubber to the front cover of the journal using crochet cotton thread and a running stitch all the way around. Go through only the first layer in the towel cover.

4 Open the cover. Stitch the raw edges of the towel closed with cross stitches.

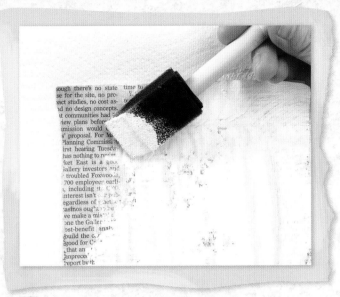

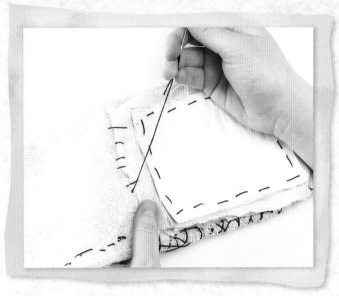

5 Determine the number of pages you want in your journal and cut twice as many pieces of newspaper measuring approximately 4½" × 5" (11.5cm × 13cm). Glue 2 pieces of newspaper together. Do this for each set of pages that will be in the book.

Paint the pages with white acrylic paint and a foam brush, leaving some of the words showing through for a worn effect. Let the paint dry.

6 Stitch each page to a slightly larger rectangle of an old T-shirt using crochet thread and a running stitch. Repeat this step for each page.

With crochet thread, stitch all the pages to the interior spine of the towel cover.

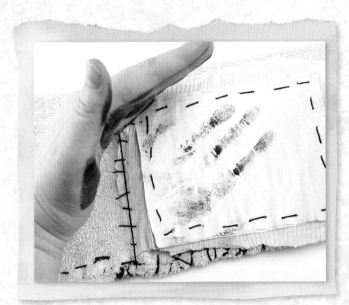

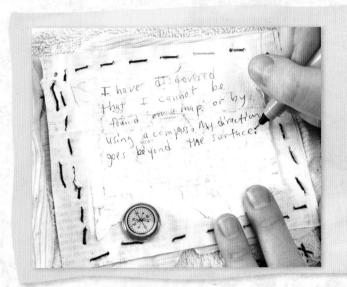

7 Embellish the spread by stamping your handprint on the page with black ink. Journal if desired.

8 Glue a portion of a map onto another page and paint over it sporadically. Let the paint dry. Sketch a compass and add journaling with fine-tip markers.

I want to be...

Simple, not in mind and body,
but in spirit. I want simplicity
to invade my soul, embracing
every pore, savoring every

Sense until I am at
ease, enjoying, inhaling life
at the roots, understanding what
life was meant to be and not
what it is. Freedom and happiness...
that is what I seek in

Simplicity
—Tammy Kushn

Simplicity

I want to live a simple life. I have studied books, read
blogs for helpful tips and done everything in between to seek
simplicity, save an arduous spiritual journey--at least not yet.
Still, I find myself caught up in the world's mundane troubles.
I still struggle with taking a step back and letting it all go.
I want a chance to watch life fly by without guilt or regret,
knowing that I am not wasting time but finding it.

MATERIALS

* acrylic word plate

* black fine-tip permanent marker

* brads

* canvas fabric

* colored pastel pencils

* dried flower

* quilt batting

* sewing thread

* tea-stained cloth

TOOLS

* awl

* craft glue

* scissors

* sewing needle

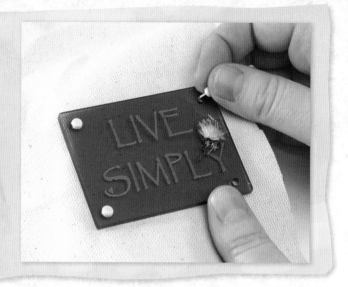

1 Cut 2 pieces of canvas, each measuring 6" × 15" (15cm × 38cm). In the lower right corner of 1 piece of canvas, punch holes that correspond with the holes in an acrylic word plate using an awl. I used a word plate with the phrase *Live Simply* and glued a dried flower to it. With brads, attach the word plate to the canvas. This will be the outer part of the cover.

2 Layer the outer part of the cover, a 6" × 14½" (15cm × 37cm) piece of quilt batting, and the other piece of canvas fabric. Stitch the book cover together using sewing thread and a whipstitch, but leave the top of the cover open.

3 Stitch a tea-stained cloth measuring approximately 12½" × 18" (32cm × 46cm) to the inside layer of the canvas fabric with a running stitch. Fold the cloth into thirds so it rests within the cover.

4 Stitch the top of the cover closed with a whipstitch.

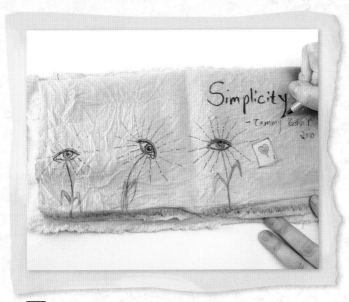

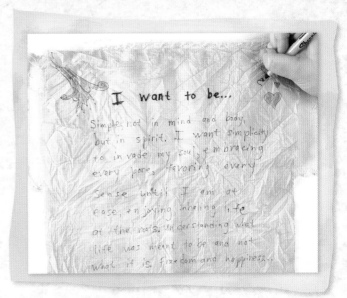

5 On the folded piece of tea-stained cloth, sketch a design with a black fine-tip marker. I sketched eyes on flower stems. Apply color to the sketch with pastel pencils.

6 Unfold the tea-stained cloth. Journal on the cloth using a black fine-tip marker. Sketch designs along the edges of the cloth.

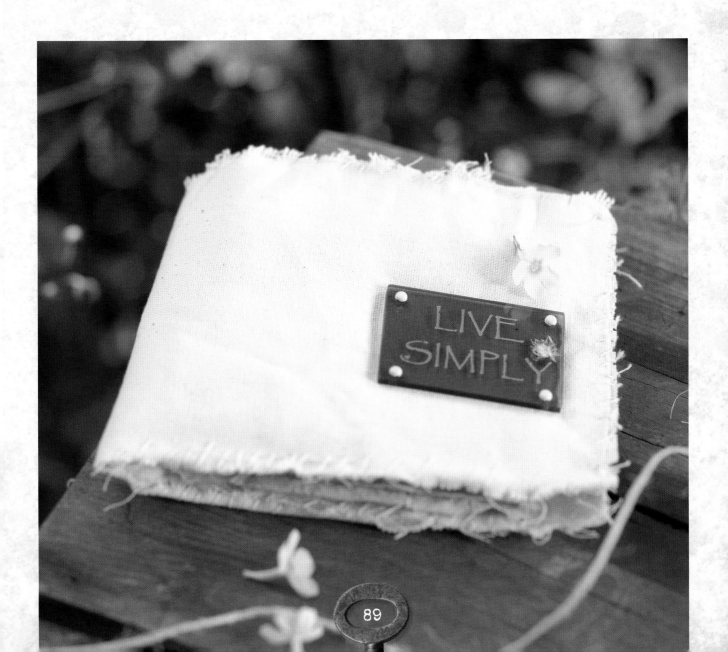

3

The number 3 is my favorite number. Why? I really couldn't say. It's not that I have had any particular amount of luck with the number 3. I've just always found it fascinating. When this book was in its infancy, the number 3 came to me, and I knew I had to include it in the project. The number itself became my purpose and held meaning for me. This journal is divided into three parts to represent the past, the present and the future. Who knew 3 could be so much more than a number?

{ CaST aSiDE }

My father came across some old childhood photos of me and gave them to me. In many of these photos, the heads had been cut off or the subject was blurry. Instead of throwing them out, I decided to incorporate them into the journal. I sanded them down and watched the colors on the photo paper blend and turn chalky. Vintage photo paper has this effect, while modern photo paper doesn't.

MATERIALS

* art paper
* brads
* cardstock
* collage images
* fusible web
* old pair of khaki pants
* old photo album
* pencil or pen
* red and white acrylic paints
* sewing thread
* straight pins
* transparency paper
* vintage personal photos
* vintage stamp of the number 3

TOOLS

* awl
* black artist tape
* craft glue
* deckle ruler
* foam brush
* sandpaper
* scissors
* sewing needle

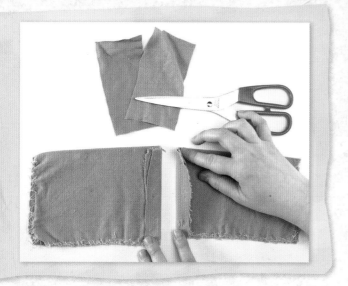

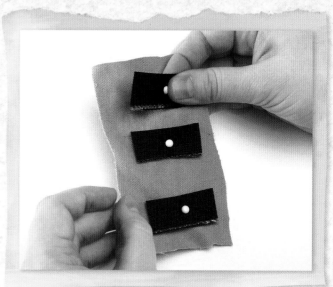

1 From a worn pair of khaki pants, cut 2 pieces of fabric measuring 7" × 8" (18cm × 20.5cm) for the front and back covers and 2 pieces measuring 2½" × 4½" (6.5cm × 11.5cm) to hold the pages. Fold the 2 larger pieces in half lengthwise, making them 4" × 7" (10cm × 18cm). For the front cover, stitch along the left edge and bottom edge and fold in the right edge ½" (13mm). For the back cover, stitch along the right edge and bottom edge and fold in the left edge ½" (13mm).

2 Cut 3 pieces of a photo album page, each measuring ½" × 1½" (13mm × 4cm). Arrange these pieces onto a 2½" × 4½" (6.5cm × 11.5cm) fabric piece and punch holes through both the fabric and photo album pieces with an awl. Attach the pieces with brads as shown. This piece will be the spine of the journal.

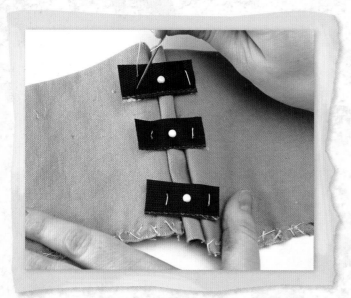

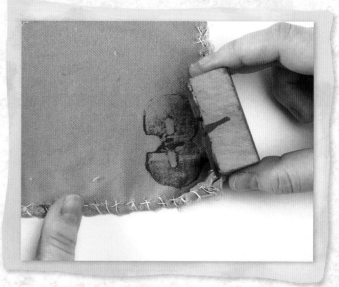

3 Fold the spine fabric lengthwise, letting the photo album pieces stick out on each side. Sew the front cover and back cover to the photo album pieces with a single straight stitch on each side as shown.

4 Dip a vintage stamp of the number 3 into red acrylic paint and stamp it on the bottom right corner of the front cover.

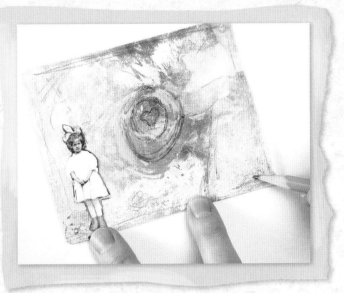

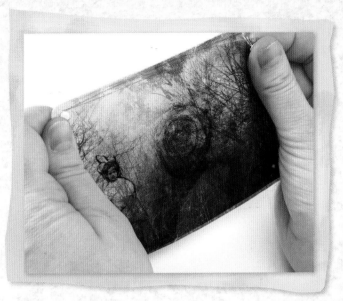

5 Sand the surface of a vintage photograph that is slightly smaller than a journal page. Print a collage image onto cardstock and cut it out. Adhere the image to the photo with craft glue. Using a foam brush, feather white acrylic paint over the photo and doodle with a pencil or pen as desired.

6 Print an image of tree branches onto a piece of transparency paper. Trim the transparency to the size of the photo and attach it with brads in each corner.

7 Cut another piece of transparency paper to fit across the bottom of the photo like a pocket. Fasten it with brads in the bottom corners.

8 Use black artist tape to seal the bottom of the transparency and photo to create a pocket in which findings can be placed.

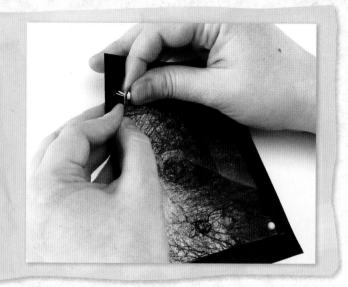

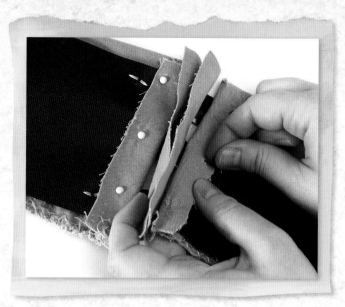

9 Cut the desired number of inside pages for the journal from photo album pages, each measuring 4" × 6" (10cm × 15cm). Fasten the photo/transparency art to a photo album page using the brads in the corners. Repeat Steps 5–9 to create the desired number of photo/transparency art pieces.

10 Slip half the photo album pages into the folded edge of the inside front cover. Attach these pages to the front cover with 3 brads as shown. Repeat this step with the remaining photo album pages and the folded edge of the back cover.

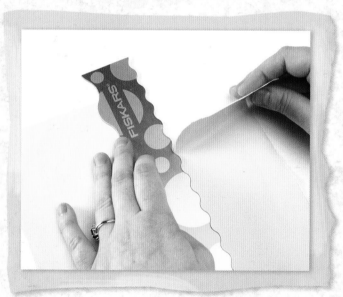

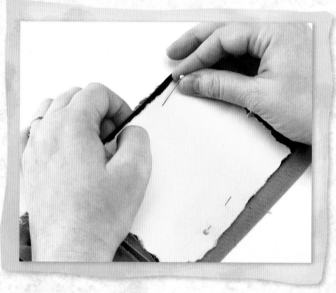

11 Tear pieces of art paper to fit within the blank journal pages using a deckle ruler.

12 Attach each piece to a blank photo album page with straight pins.

inspiring hint

For the photo/transparency art pieces, use old images that you don't mind sanding. Try sanding in different directions and with lighter or firmer applications of pressure for great effects!

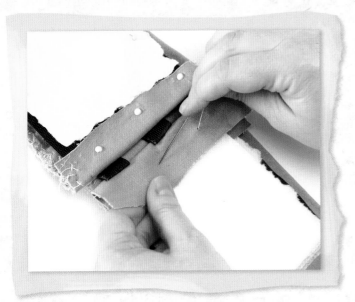

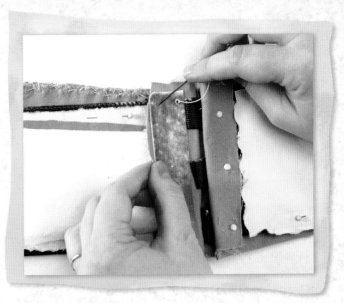

13 Cut several pieces of fusible web measuring 2" × 4" (5cm × 10cm) and place them over the remaining 2½" × 4½" (6.5cm × 11.5cm) fabric piece. Sew this stack in between the inner spine pieces.

14 Cut a sanded scrap piece of a vintage photograph to fit 1 side of the spine fabric. Stitch the scrap piece to the spine fabric with a horizontal straight stitch at the top and bottom. Slip a small pencil beneath these stitches.

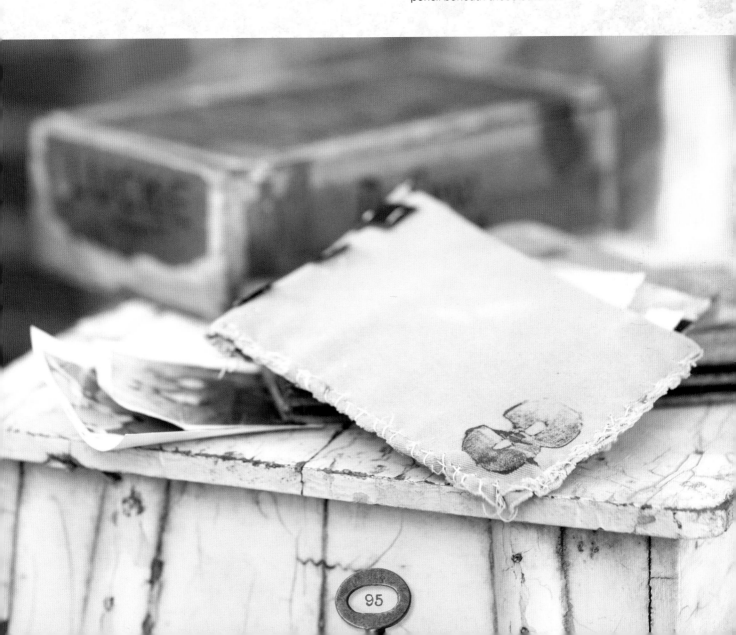

Warm Comfort

Geraldine Newfry

Handmade felt provides the covers of *Warm Comfort*. The wool was rescued from a petting zoo, hand-dyed and transformed into felt. The deckled-edged, blue-and-white pages were given to me by a friend. The journaling focuses on things that bring warm comfort to me, including knitting and tea. The book was bound using a variation of the long stitch.

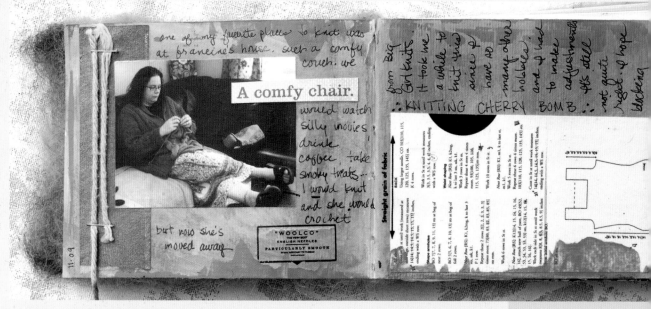

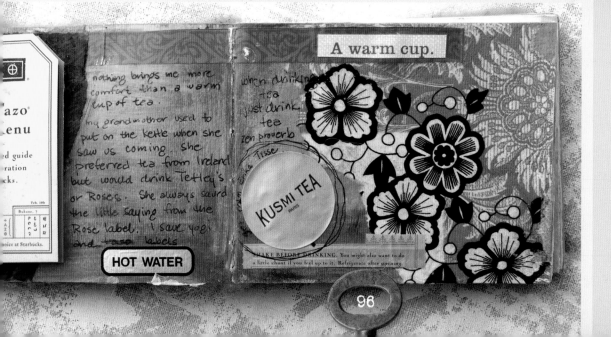

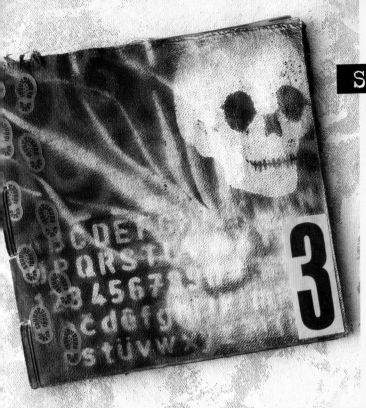

Stenciled and Quoted

Geraldine Newfry

Inspired by street art and a wonderful class by Mary Ann Moss of Dispatch from LA, *Stenciled and Quoted* was created with handcut and commercial stencils and spray paint. The cover was created from a discarded drop cloth. The papers are cardstock from my collection. The images inspired the quotes. The book was bound using a variation of the long stitch.

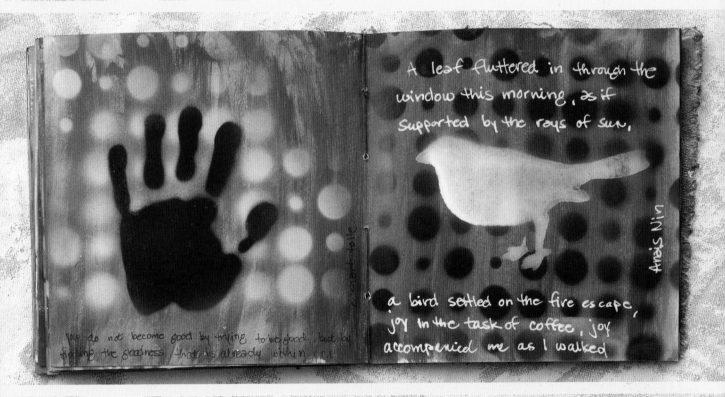

A leaf fluttered in through the window this morning, as if supported by the rays of sun,

a bird settled on the fire escape, joy in the task of coffee, joy accompanied me as I walked

Anais Nin

you do not become good by trying to be good, but by finding the goodness that is already within

The miracles of nature do not seem miracles because they are so common.

Pocket Full of Love

Jen Osborn

I try to approach writing and making art the same way I approach life: every moment of creating, every new idea and spark of inspiration, is a gift I've been given to share. I love trying to do the impossible with my stitched mixed-media art, such as with this journal. I love trying to stitch the odd and unusual: if it will fit under my sewing machine foot I'm going to try and sew it onto fabric or paper. If it doesn't fit, I just grab my Dremel, needle and thread and run with the stitches. Here, I've done that by sewing photos onto an old pair of my husband's camouflage shorts along with paper, feathers and other odd objects. I always try to appreciate the rules of art and sewing and then figure out how to break them. My advice to anyone wanting to create is to roll up your sleeves and get messy. Forget all the rules you've been taught, go out on a limb and try something new. Do things "they" say can't be done, but, most of all, just GO MAKE ART!

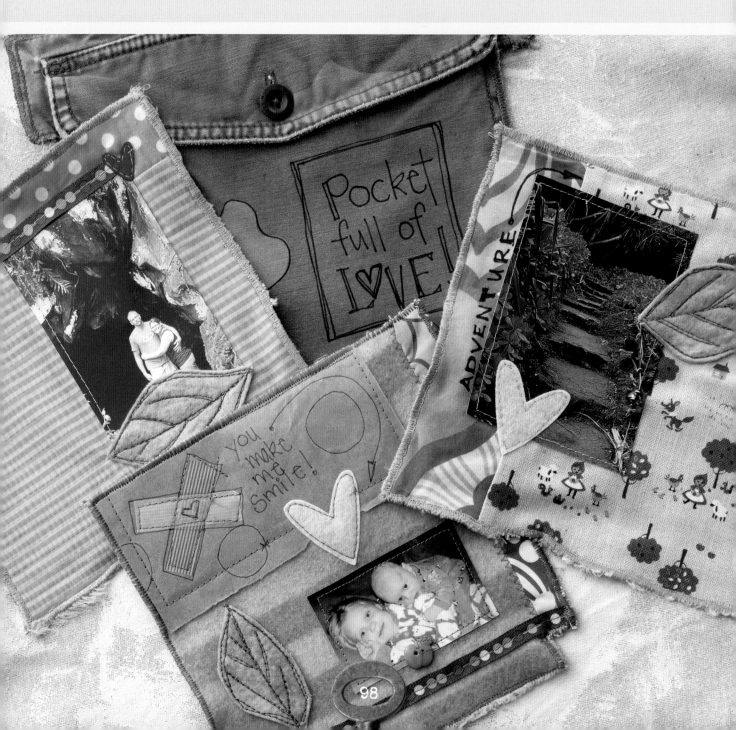

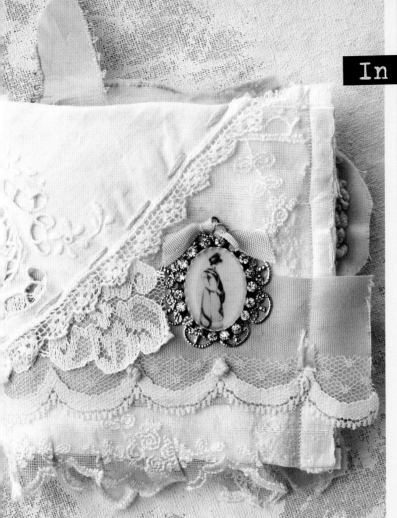

Kristen Robinson

My studio is filled with baskets of vintage and antique fabrics. I am enchanted by the amazing textures and secrets these textiles hold, and I knew an upcycled journal would be the perfect way to pay homage to these treasures.

The journal cover is crafted from an antique handkerchief. An old sweater vest that I felted in the washing machine adds not only strength to the structure of the journal but also a sense of serenity and calmness. Layers of silk and old ribbons intertwine with watercolor paper and scraps of fabric, offering places to journal and place notes. The journal is held together with a bit of hand and machine stitching. I find great comfort in this warm little journal. The juxtaposition of textures and fabrics reminds me to play within the pages, dream and be true to all things.

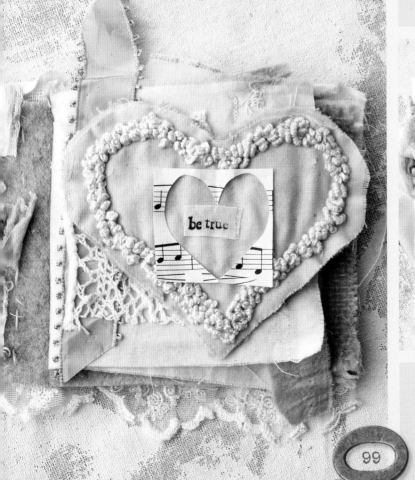

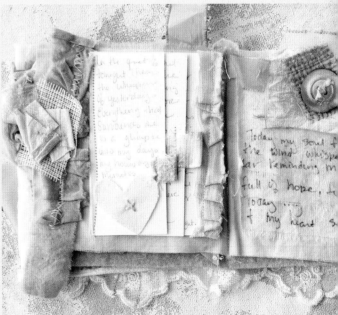

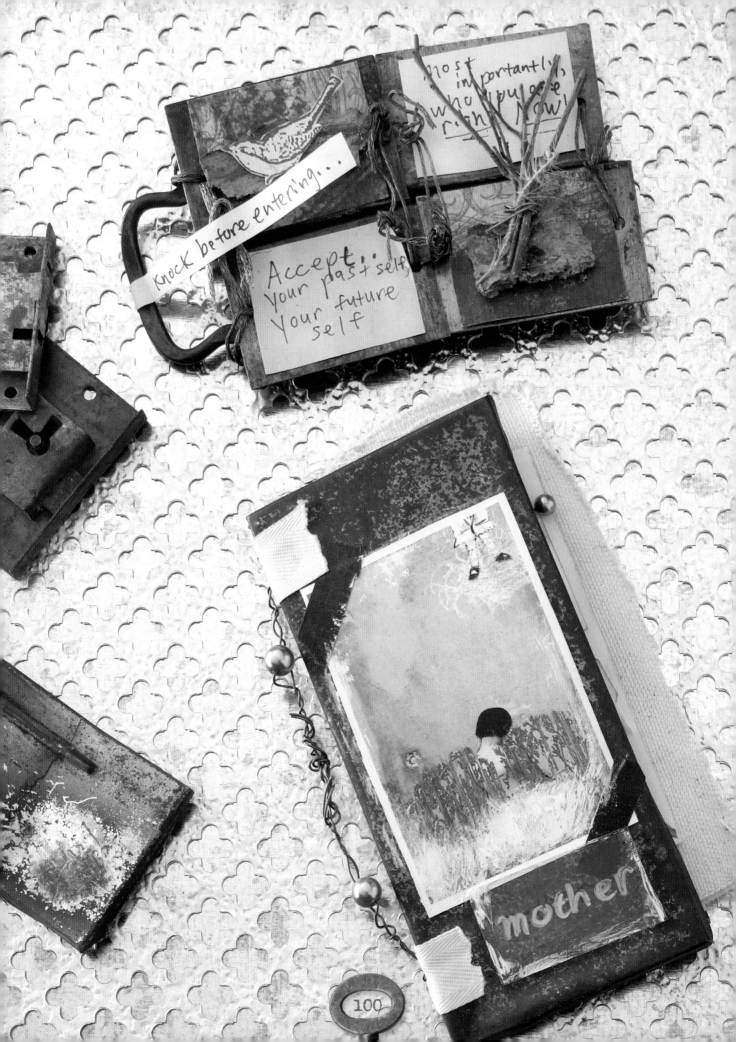

Knock before entering...

most importantly,
who you are
rich Now!

Accept
your past self,
your future
self

mother

5 *metal*

When I used to think of metal, I often thought of large
and bulky pieces that would only fit on a flatbed truck
or in storage centers. Metal findings are more prevalent
than we think: old padlocks, dented metal boxes, gears
from rusted machines and discarded jewelry abound.
Metal is a shiny treasure that has a myriad of uses in
journal making. When searching for metallic materials
to use in your own journals, look in your garage and
kitchen. There is sure to be a shiny, neglected treasure
just waiting for you.

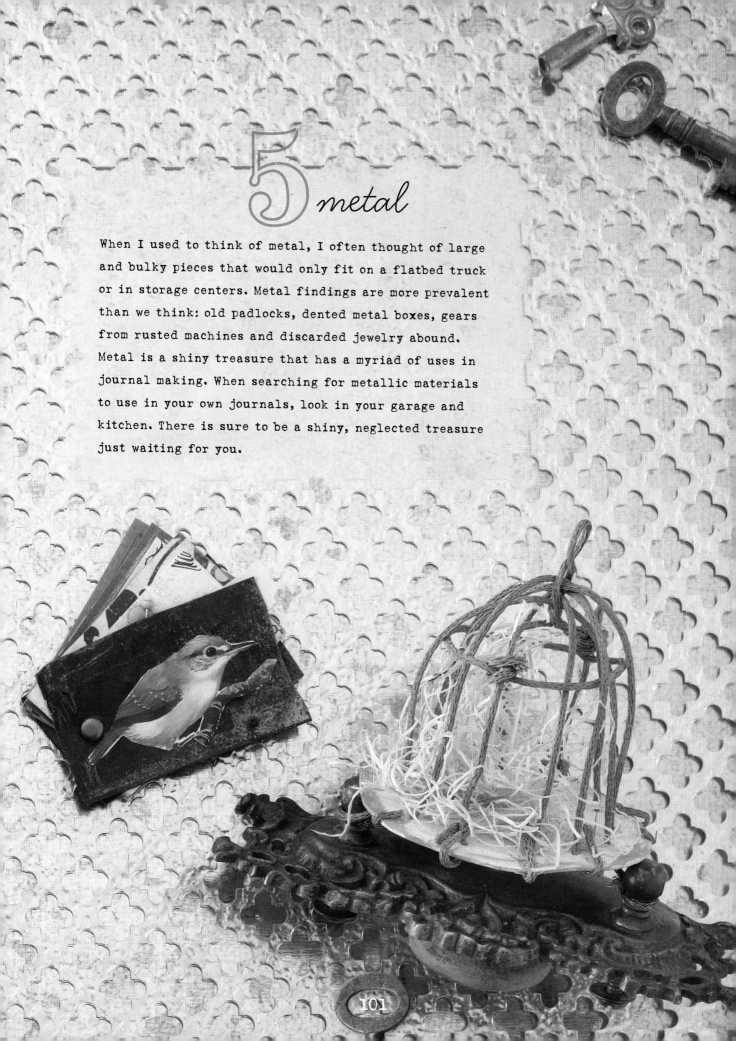

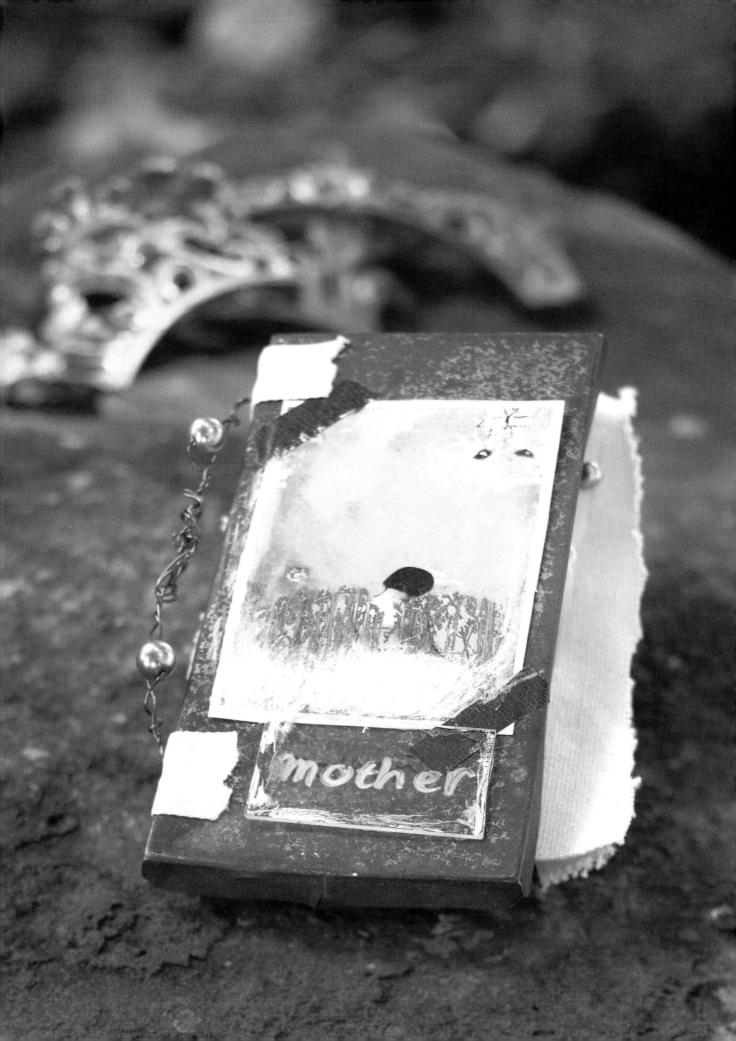

Mother

I am the mother of two small boys. Motherhood has not always been an easy journey. There are days when I don't think I can do it, and times when I think I must have made a horrible mistake that will scar my children for life. Yet, each day my boys come back to me with open, loving arms, and I know it can't be as bad as I think it is. Motherhood is a series of ideals. We all have high expectations for our children and what we want for them. Sometimes we also have to learn to accept things as they are and know that we are doing our best.

{ CaST aSiDE }

Some metal is easily cut and molded, such as the metal covers used in this project, which came from a vintage rusty box that was thin enough to be cut using heavy-duty scissors. A variety of metal boxes, including vintage jewelry boxes and pill boxes, can be used in this project. Keep in mind that the metal must be thin enough to cut with heavy-duty scissors. Always use caution when cutting metal.

MATERIALS

* 26-gauge copper wire
* baby bracelet
* beads
* black artist tape
* brads
* buttons with two holes
* canvas
* collage images
* Distress Ink in Vintage Photo (Tim Holtz)
* fabric heart
* glass slide
* manila folder
* patterned paper
* personal photos and drawings
* ribbon
* rub-ons
* safety pins
* small paper tag
* straight pins
* thin, malleable pieces of scrap metal
* twill tape
* white acrylic paint

TOOLS

* awl
* craft glue
* foam brush
* heavy-duty scissors
* scissors
* sponge for applying ink

103

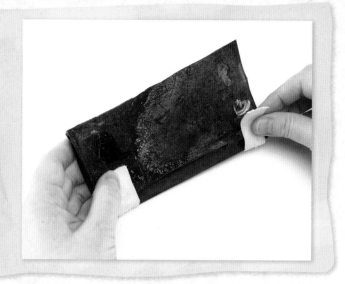

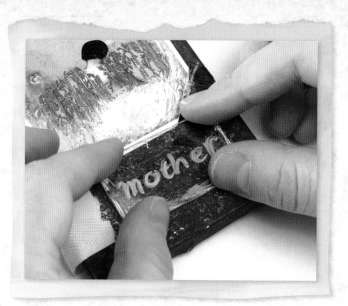

1 For the cover, use 2 pieces of scrap metal of the same thickness measuring 5" × 7" (13cm × 18cm). Or, using heavy-duty scissors, cut 2 thin, same-size pieces from a metal box. Place the pieces together to create a front and back cover. Cut 2 strips of twill tape approximately 3" (7.5cm) long and glue them to the edges of the covers as shown to create a spine.

2 Create a small collage using photos and drawings of significance. Attach the collage to the front cover with black artist tape and feather the edges with white acrylic paint and a foam brush. Feather acrylic paint along the edges of a glass slide and write the word *mother* in paint. When the paint is dry, glue the slide beneath the collage.

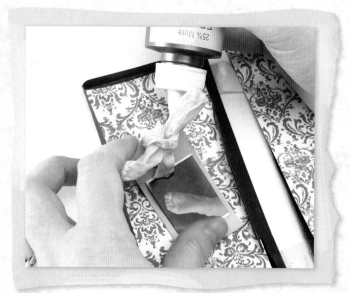

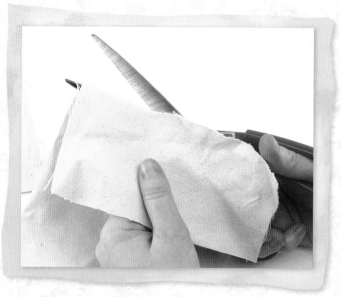

3 Cut pieces of patterned paper to fit the inside covers and glue them to the metal. Tie a piece of ribbon to a small paper tag and adhere a personal photo to the tag. Glue a fabric heart in the lower left-hand corner of the tag. Glue the finished tag to the inside of the front cover.

4 Cut out the desired number of 5" × 7" (13cm × 18cm) pages from canvas. It's okay if the edges are frayed; it will give the journal a weathered look.

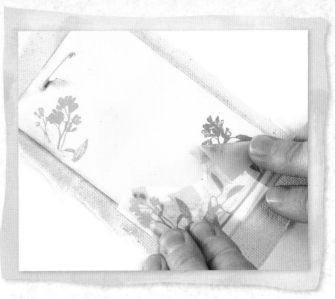

5 Cut out 4" × 6" (10cm × 15cm) pieces from a manila folder to fit over some of the fabric pages. Ink the edges of each piece using a sponge.

6 Attach the manila folder pieces to some fabric pages with safety pins. Apply rub-ons around the edges.

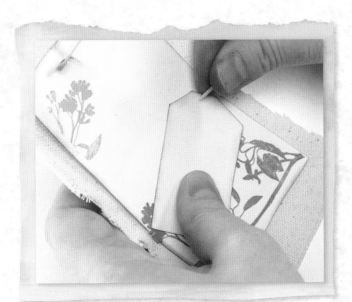

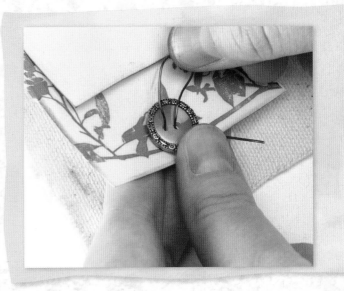

7 Trace a small tag onto the manila folder, cut it out and ink the edges. Attach it to a page using a brad. Create different-shaped tags and attach each one to a journal page with a manila folder piece.

8 Cut a 2" (5cm) piece of 26-gauge copper wire for each page. Using an awl, poke 2 holes through the bottom of each manila piece and attach a button using the wire piece.

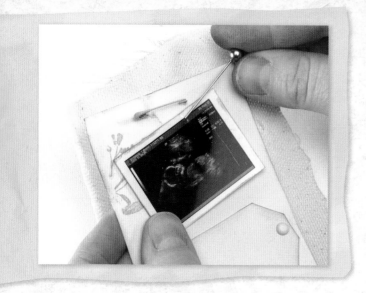

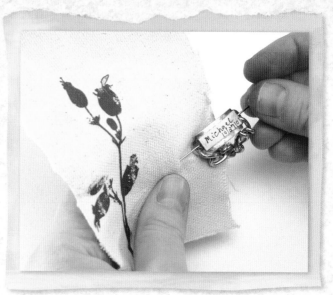

9 Make a small photocopy of your baby's ultrasound. Ink around the edges and pin it to 1 of the pages with a straight pin.

10 Apply rub-ons to the sides of the pages that do not have manila pieces. If you have special items or mementos from your baby's birth, such as a baby bracelet, attach them to the pages with straight pins.

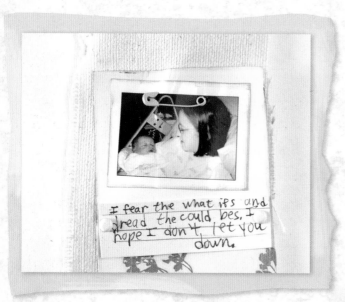

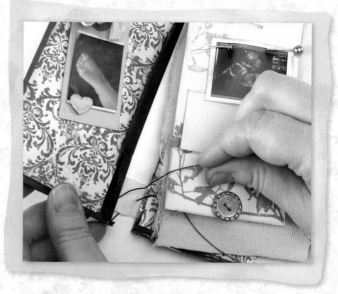

11 Add other personal photos to the remaining pages with straight pins or safety pins.

12 Cut 2 pieces of copper wire, each measuring 15" (38cm). Open the journal. Thread 1 piece of wire up through 1 of the twill tape pieces attached to the cover, through all the canvas pages, and then back down through the twill tape, adjusting the wire on the outside of the book so the ends are equal lengths. Repeat this step for the other piece of twill tape.

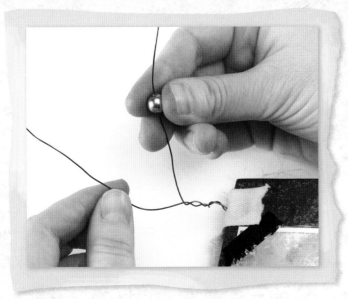

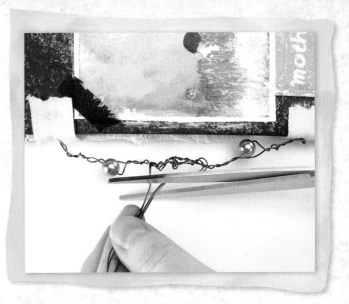

13 Begin twisting the wire at the top of the journal. Halfway through twisting, thread a bead onto 1 end of the wire, and then continue twisting to the end. Repeat this step for the bottom wire.

14 Twist the top wire and the bottom wire together at the middle of the book until the pages within feel secure. Trim the excess wire.

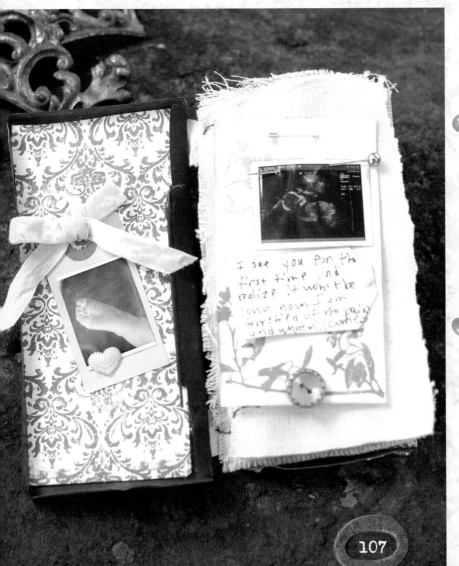

inspiring **hint**

When creating a *Mother* journal, choose the moments that mean the most to you and that ache to be journaled, even if you don't have photos of them.

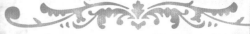

Birdcage Memories

I love birdcages. They hold a fascinating symbolism to me. In this case, the birdcage was created out of galvanized wire and vintage hardware. We all make our own cages, so the saying goes, and this time the saying is very literal. But what to put in the cage? Now that is the question, and the answer is: journal cards!

MATERIALS

* bookbinder's board
* brad
* clothing tag
* collage images, including a bird image
* colored pencils
* feathers
* fine-point marker
* galvanized metal wire
* miniature fabric heart
* newsprint paper
* ornate brass plate
* patterned paper
* small doorknob or circular wooden finding
* soft shredded wood
* straight pin
* thin scrap metal
* white and gold acrylic paints

TOOLS

* awl
* craft glue
* heavy-duty scissors
* paintbrush
* scissors
* wood or metal glue

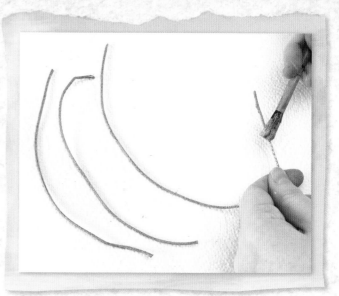

1 From a clothing tag, cut out a circle with a 3" (7.5cm) diameter. Paint the circle with white and gold acrylic paints. Punch 12 holes evenly around the edge of the circle using an awl.

2 With heavy-duty scissors, cut 7 pieces of galvanized metal wire, each measuring 7" (18cm). Paint the pieces with gold acrylic paint.

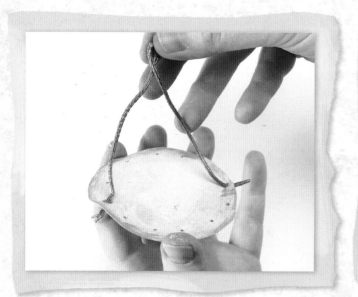

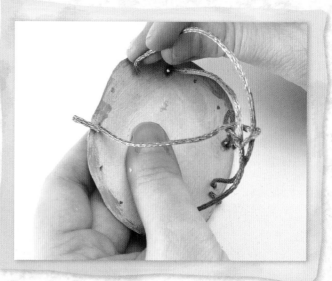

3 After the wire pieces are dry, thread 1 piece through a hole in the cage base. Form a U shape over the base and thread the other end of the wire in the hole directly across from the first hole. Twist the wire once at the center, creating a loop. (Do not secure the wire ends on this first piece, as they will be needed later.)

4 Repeat Step 3 with 5 more wire pieces. As you bring each wire across the circle, thread it through the loop made in the first wire. For each of these wires, bend the ends up and around the edge of the circle to secure them. When the basic form is finished and all the holes have been used, wrap the remaining piece of wire around the top portion of the birdcage, weaving it through the bars and twisting to secure it.

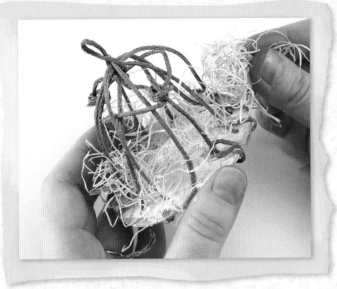

5 Glue soft shredded wood and tiny feathers to the base of the cage.

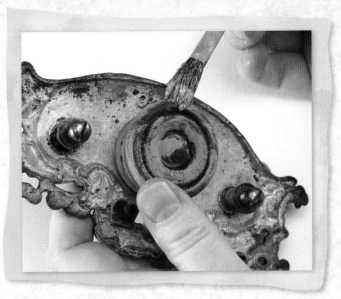

6 Glue a doorknob or a circular wooden finding to the base of an ornate brass plate using wood or metal glue.

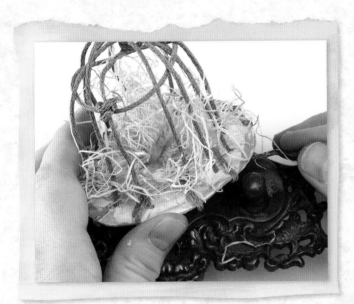

7 Using the unsecured wire ends from the first piece of birdcage wire, secure the cage to the knobs on the brass plate.

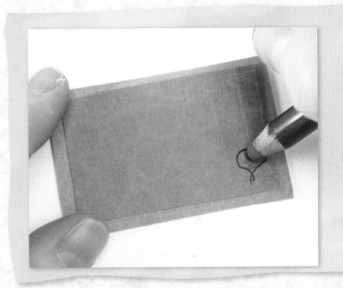

8 Cut the desired number of pages for the journal from bookbinder's board, each measuring 2" × 3" (5cm × 7.5cm). Cut and glue pieces of patterned paper to both sides of each page. Add doodles with colored pencils or glue collage images to the pages as desired.

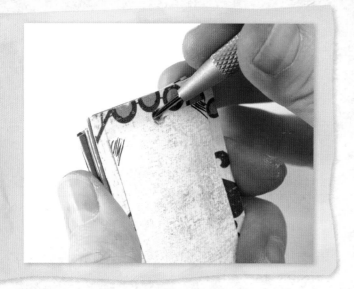

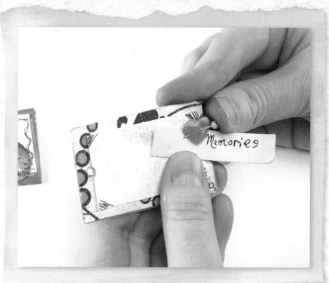

9 Using an awl, poke a hole through the left side of each page.

10 Cut a strip of newsprint paper and write the word *Memories* on it. Attach this strip, along with a miniature fabric heart, to the first page with a straight pin.

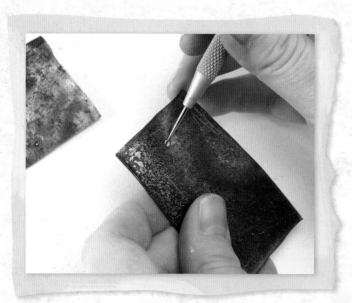

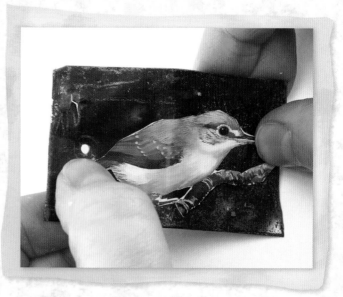

11 Cut 2 pieces of thin scrap metal, each measuring 2" × 3" (5cm × 7.5cm), for the covers. Using an awl, poke a hole through the left side of each cover.

12 Glue an image of a bird to the front cover.

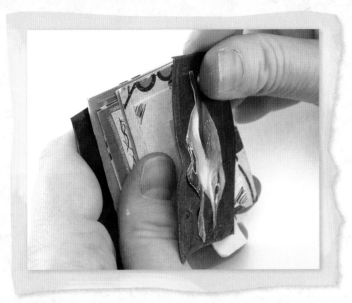

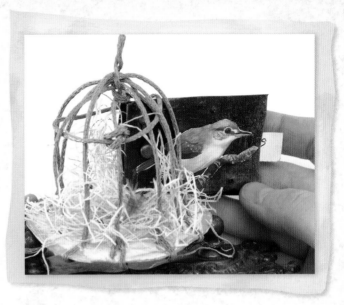

13 Sandwich the pages between the front and back covers. Attach the covers and pages by pushing a large brad through the holes in the left-hand side.

14 Slide the book in between the bars of the cage to secure it.

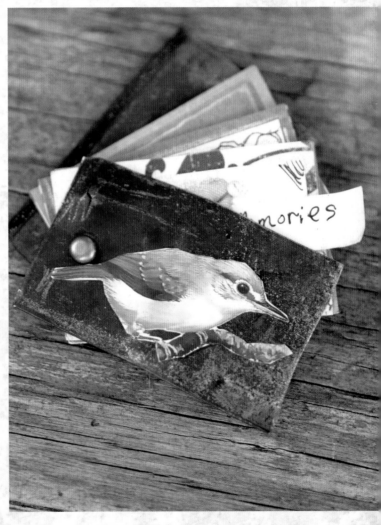

inspiring hint

Are birds not your thing? Find out what is. Use a single image as your source of inspiration and make a home for your art, just as this cage is a home for the bird journal.

Knock before entering...

Accept...
your past self,
your future
self

Most
importantly
who you are
right now!

Knock Before Entering

I have always considered the phrase "Knock Before Entering" to be an important one, since it emphasizes a sense of privacy and secrecy and is a phrase that even the most outgoing person uses. This journal was born out of that need for privacy. After the viewer has "knocked," she is allowed to see the inner book, where my personal messages and thoughts have been written. However, there are no concrete or definite phrases, and the true meaning of my inner thoughts is still known only to me.

MATERIALS

* antique drawer locks
* bark, twigs, dried flowers and other natural findings
* black fine-tip permanent marker
* galvanized wire
* metal handle
* newsprint paper
* patterned paper
* rub-on of a bird
* scrap of cardboard

TOOLS

* craft glue
* heavy-duty scissors
* scissors

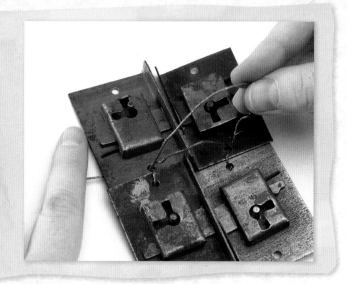

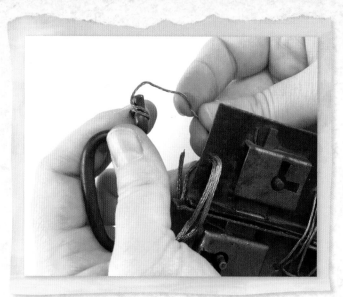

1 Lay 4 antique drawer locks side by side, with the locks facing up. With heavy-duty scissors, cut 3 pieces of wire, each 10" (25.5cm) long. Weave the wire pieces through the holes in the locks, going from left to right, to connect them. These locks will serve as the cover of the book.

2 Cut 3 more 10" (25.5cm) pieces of wire and thread them through the holes in the locks, going from top to bottom, to secure the book. Using wire, attach a small metal handle to the left side of the front cover.

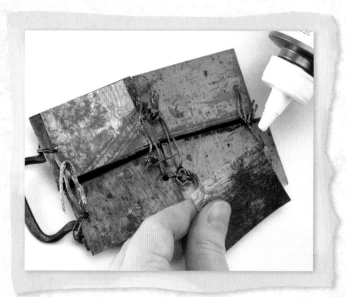

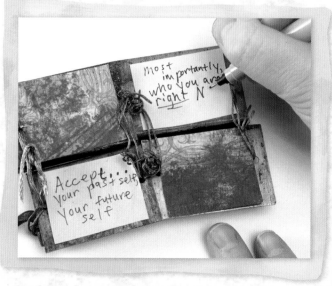

3 Cut 2 pieces of patterned paper to fit the flat sides of 2 of the drawer locks. Glue the paper to the top left and bottom right locks inside the book.

4 Cut newsprint paper to fit the flat sides of the remaining 2 drawer locks and glue the paper to the locks. Write personal messages on the newsprint paper with a black fine-tip permanent marker.

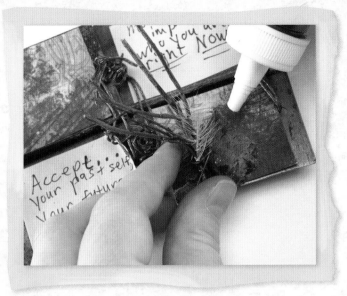

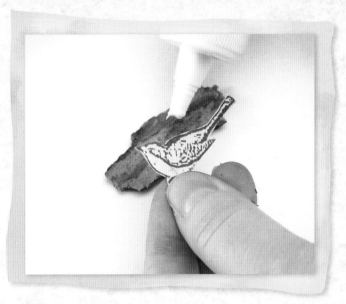

5 Tie a bundle of twigs, dried flowers and other natural findings using galvanized wire. Glue the bundle to a piece of tree bark. Glue the bark to the paper on the bottom right lock.

6 Glue a rub-on of a bird to cardboard and trim the cardboard to the bird's shape. Glue the bird to another piece of bark. Glue the bark to the upper left lock.

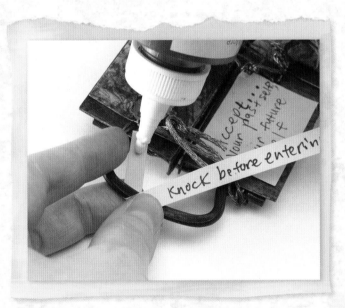

7 Cut a thin strip of newsprint paper and write the phrase *Knock Before Entering* on it. Wrap the strip once around the handle of the book and secure it with glue.

inspiring hint

If you decide to make a journal about privacy but still feel the urge to share it with someone, include a phrase that only you understand. It can be something obscure, such as a personal memory or a promise made to yourself.

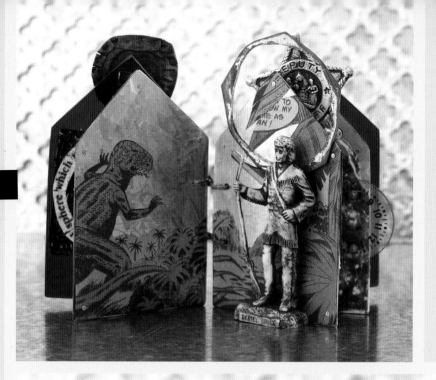

Zero to Twelve

Judith Hoffman

Zero to Twelve is an homage to my childhood. I loved stars and the cicadas that sang in the summer trees. I remember looking out a little window in my uncle's room to see the maple trees and yards behind my grandparents' house. I was fascinated by dinosaurs, comic books, cowgirls, Daniel Boone, and watching frogs and salamanders in any nearby creek or pond. And by a stroke of random luck, I wound up living in California as an adult. Life is strange.

To make this book, I searched through all my small objects for things that evoked childhood memories. Then I started playing with them in different arrangements. The Plexiglas was lightly sanded with used sandpaper to make it translucent. The numbers were cut out with a jeweler's saw. Objects were attached with rivets, tiny nuts and bolts and heavy-duty adhesive.

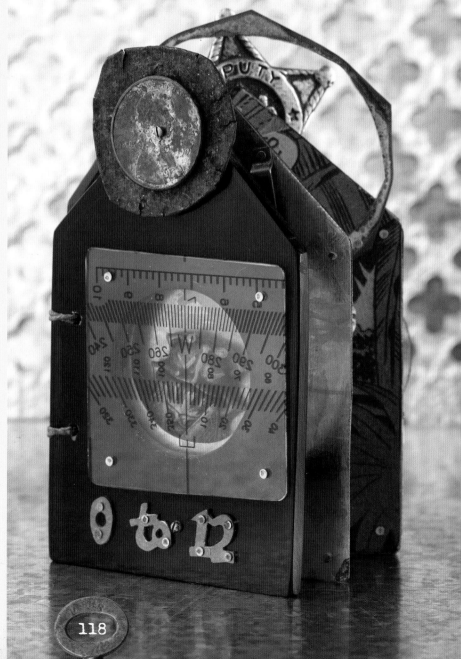

Fern Book

Judith Hoffman

This *Fern Book* is part of a series inspired by my childhood interest in dinosaurs and the tree ferns of the hot, humid Late Cretaceous epoch. It amazes me that the ferns in my garden are descended from the tree ferns of the dinosaur era. The little collaged photos of ferns and other plants were taken in my yard with a pinhole camera I made from a matchbox. They are tiny, scratched windows looking into the Late Cretaceous period. The copper shapes for the cover were cut out with a jeweler's saw. They were etched and then annealed, so I could hammer them to curl the leaves. For the pages, I colored the paper with acrylics and colored pencils, then drew the ferns on with pen and ink. I included a table of contents, chapters and page numbers because I love the structure of books.

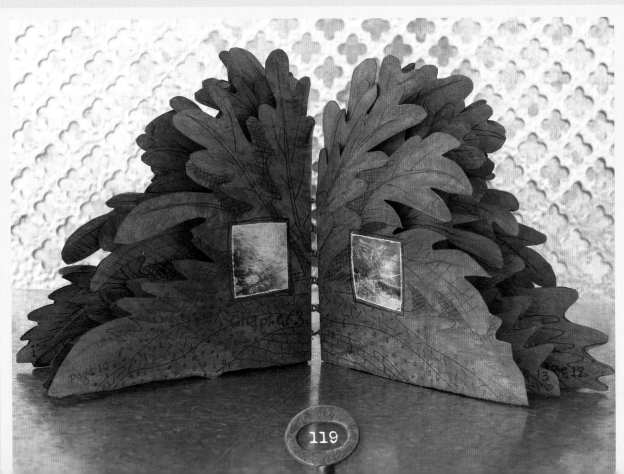

Jill Berry is a mixed-media artist, teacher and mom in the Rocky Mountains who makes storytelling structures. Her work involves social issues, maps, symbols, houses, housewives and the mystique of charisma, and can be seen in *Letter Arts Review*, *Somerset Studio*, *Art Journaling* and *In Flight* magazines; in *Interactive Workshop: Mixed Media in Motion* by Kim Rae Nugent and *Drawing Lab* by Carla Sonheim; and in various other books and magazines. Her handmade books are in the collections of the Newberry Library in Chicago and the Denver Public Library, and private collections nationally. She has taught at three universities and other institutions nationally and she feels that art is essential! She is currently writing a mixed-media mapmaking book for North Light.

Tonia Davenport is a mixed-media artist, jewelry designer and the Acquisitions Editor for North Light Craft Books. In addition to *Frame It!*, she has published a second book, *Plexi Class*, which reflects her passion for working with Plexiglas. Tonia teaches workshops here and there and when she's not making art, cooking, reading or doodling, you can always find her on Facebook.

Sarah Fishburn's art has appeared in over two dozen books, and she has written two books, too. She currently works at a preschool, a gym and a coffee house. Whenever she has a few hours off, though, she likes to moonlight as a mixed-media narrative artist and publisher of *Pasticcio*, a cutting-edge arts zine.

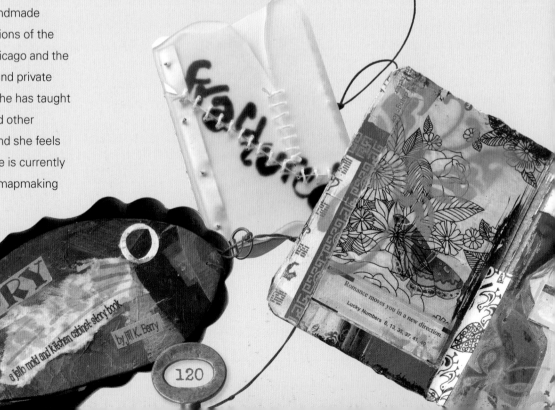

Judith Hoffman grew up with books as friends because of her parents' frequent moves. She spent much of her time drawing, making things, and reading. In college, while studying painting and drawing, she used ball chains and painted ribbons to bind small collages into books. Jewelry skills led to making metal people-shaped books with metal pages in their chests. She has been working in both metal and paper ever since. She now lives in San Mateo, California, with her artist/engineer husband and two cats. Her studio is a pine-paneled rumpus room that previous owners added to the house around 1950.

Karen Michel is a mixed-media artist and the author of *The Complete Guide to Altered Imagery* and *Green Guide for Artists*. She creates work from recycled and repurposed materials, mojo and sunshine. She and her artist husband run the Creative Art Space for Kids Foundation, a nonprofit art center for kids in New York, as well as the Haiti Relief Fund, which plays a vital part in rebuilding communities in Haiti. When not creating, you can usually find her and her 4-year-old assistant hunting seashells and locomotives.

Geraldine Newfry has been keeping a journal since she was nine. She began adding art to her pages in 1991. Always searching for the best book with the best paper, she started binding her own books in 2001. Her media include polymer clay, metal, acrylics, spray paint, handmade paper and knitted items. Her work has been published in numerous books, including *500 Handmade Books* and *400 Polymer Clay Designs*. Geraldine lives in Chicago with her husband, John, and their two kitties.

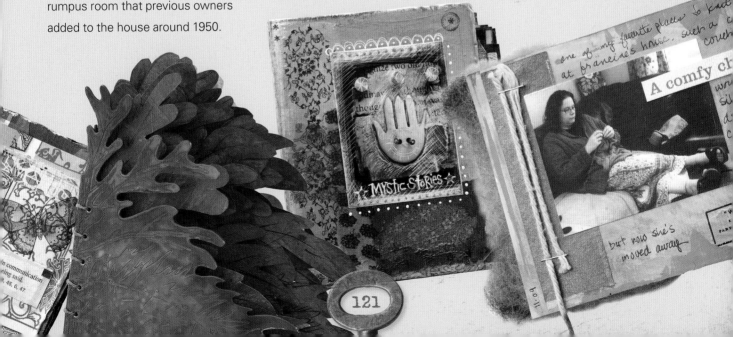

Jen Osborn is a third generation artist and author who lives in rural Michigan. She creates artwork that's as fun to touch as it is to look at. Jen has a knack for blending quirky vintage items with modern techniques, resulting in a burst of colorful eye candy. She was a columnist for *Art Quilting Studio*, recently began publishing with *Cloth Paper Scissors*, and is writing a book for North Light Books entitled *Mixed and Stitched*, which will hit bookshelves in June 2011.

Kristen Robinson is on the artistic journey of her life, one she compares to dancing through the pages of a history book. With a love for all things from the past, she is drawn to many different forms of art, from jewelry and textiles to painting and collage. Kristen is penning her first book to be published with North Light Books.

In addition, she is a Director's Circle Artist for *Somerset Studio* as well as a Bonne Vivante for *Somerset Life*. As a nationally known instructor and artist she is truly finding great joy in sharing her journey with others. You can find her online at http://kristenrobinson.typepad.com.

Susan Tuttle is a mixed-media and digital artist who resides in a small-town community in the Midcoast region of Maine. Her first book, *Exhibition 36: Mixed-Media Demonstrations + Explorations*, was released by North Light Books in December 2008, and her second book, *Digital Expressions: Creating Digital Art with Adobe Photoshop Elements*, a technique-based publication on digital art, was released by North Light Books in April 2010. Susan is a frequent contributor to Stampington & Company publications and other mixed-media books. You can visit her website at http://ilkasattic.com and her blog at www.ilkasattic.blogspot.com, through which she offers online digital art workshops on the subjects of photo manipulation, digital montage and a variety of Photoshop techniques.

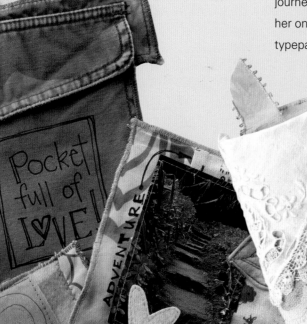

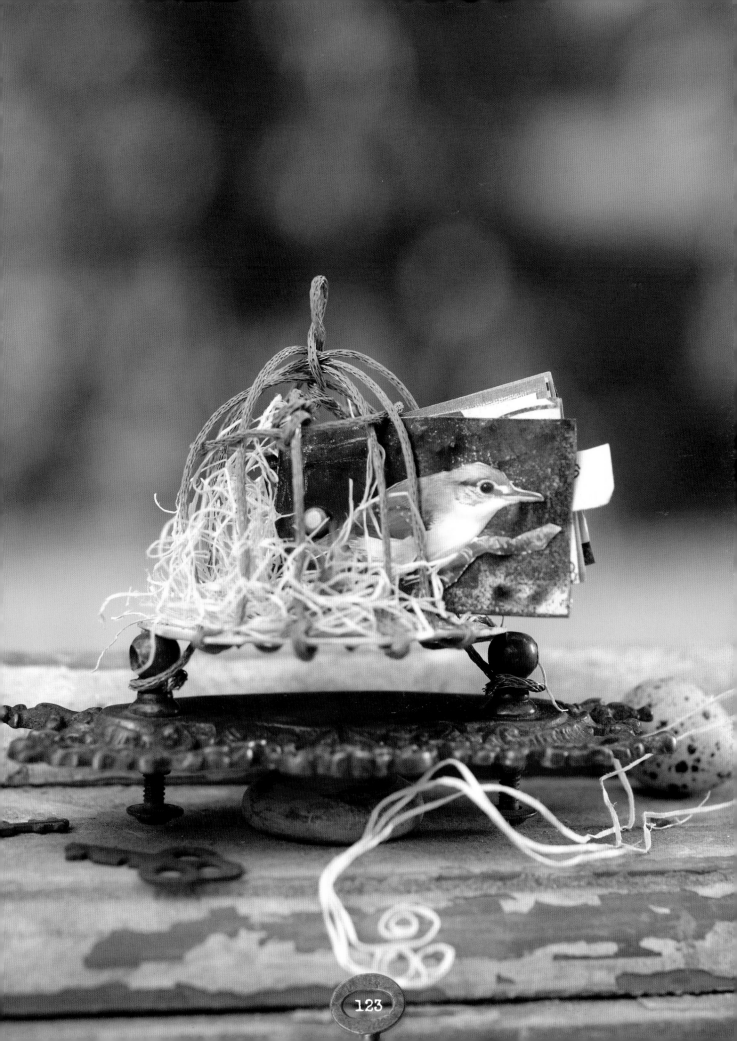

resources

Altered Pages Collage Sheets
www.alteredpages.com
collage images

American Crafts
http://americancrafts.com
801.226.0747
brads

Anima Designs
www.animadesigns.com
rubber stamps and vintage supplies

BasicGrey LLC
www.basicgrey.com
801.544.1116
patterned paper

Berwick Offray LLC
www.berwickindustries.com
800-237-9425
ribbon

Catslife Press
www.catslifepress.com
541.902.7855
rubber stamps

Chatterbox
www.chatterboxinc.com
877.749.7797
rub-ons

Crate Paper
www.cratepaper.com
801.798.8996
patterned paper

Darice
www.darice.com
800.321.1494
metal charms and soft shredded wood

DBJ Miniatures
www.dbjminiatures.com
909.984.4354
dollhouse furniture, miniature birdcages

Derwent
www.pencils.co.uk
+44(0)1900.609599
pastel colored pencils

Digital Collage Sheets
www.digitalcollagesheets.com
collage images

Digital Imagery Plus
www.digitalimageryplus.com
collage images

Doris Dotz
www.etsy.com/shop/DorisDotz
miniature figurines

Ebay
www.ebay.com
a wide variety of found objects

Etsy
www.etsy.com
handmade and vintage items

Everything Vintage
www.e-vint.com
collage images

Faber-Castell
www.faber-castell.us
800.642.2288
drawing pencils

Fire Mountain Gems and Beads
www.firemountaingems.com
800.355.2137
gems, beads and jewelry-making supplies

Grafix
www. grafixarts.com
216.581.9050
transparency paper

Heidi Grace
www.cleverfromheidigrace.com
253.507.8129
rub-ons, acrylic plates with text

K&Company
www.kandcompany.com
scrapbooking supplies

Making Memories
www.making memories.com
801.294.0530
brads

My Mind's Eye
www.mymindseye.com
800.655.5116
patterned paper, rub-ons

Navel Jelly Studios
www.naveljellystudios.com
207-285-3455
metal boxes, plastic vials

OOK, Professional Picture Hangers
www.ooks.com
artwork hanging and exhibition products

Papier Valise

www.papiervalise.com

403.277.1802

wooden tags, vintage findings, brads, envelopes, straight pins, beads

Plaid

www.plaidonline.com

800.842.4197

acrylic paints, craft supplies

Quietfire Design

www.quietfiredesign.com

rubber stamps and supplies

Ranger Industries Inc.

www.rangerink.com

732.389.3535

ink

Scrap Within Reach

www.scrapwithinreach.com

602.758.5262

patterned paper

Sharpie

www.sharpie.com

800.346.3278

permanent fine-tip markers

Stampington & Co.

www.stampington.com

877.782.6737

mixed-media supplies, velvet ribbon

Tim Holtz

www.timholtz.com

Distress Ink

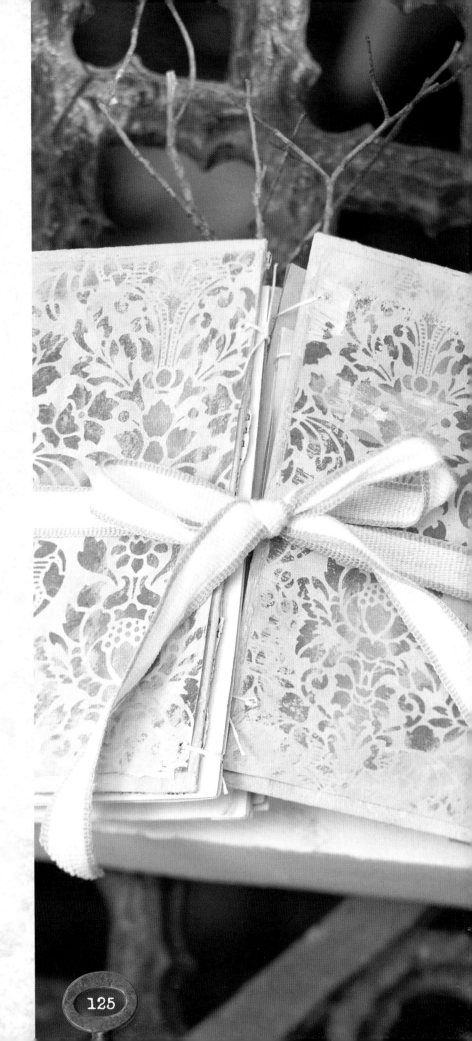

index

write your story in art with

North Light Books

Book + Art

Dorothy Simpson Krause

Take a guided tour through a wide variety of binding techniques and structure styles, topped off with plenty of inspiration for transforming books into works of art. Techniques range from collaging directly in a premade book to printmaking to making concertinas. See the form and function of a book in a new light, as you view it as a new form of creative expression.

paperback with flaps

144 pages

ISBN-10: 1-60061-154-0

ISBN-13: 978-1-60061-154-4

Z2489

Creative Awakenings

Sherri Gaynor

What if you could unlatch the doors to your heart and allow yourself to explore hopes and dreams that you haven't visited for a very long time? *Creative Awakenings* is the key to opening those doors, showing you how to use art making to set your intentions. You'll learn how to create your own Book-of-Dreams Journal and a variety of mixed-media techniques to use within it. You'll also get inspiration from twelve artists who share their own experiences and artwork created with the Art of Intention process.

paperback

144 pages

ISBN-10: 1-60061-115-X

ISBN-13: 978-1-60061-115-5

Z2122

Objects of Reflection

Annie Lockhart

Objects of Reflection embodies visual journaling by creating art that is so personal it resembles a page from the artist's journal. Inspiration pours from every page of the book through a gallery of projects designed by the author. In addition, over 20 step-by-step techniques include tips for attaching elements with simple materials like string, wire and tape, aging objects, adding texture with modeling paste and more. You'll learn how to tell your own stories through your art as you turn symbolic objects into your "words."

paperback

128 pages

ISBN-10: 1-60061-331-4

ISBN-13: 978-1-60061-331-9

Z2974

These and other fine North Light titles are available at your local craft retailer, bookstore or online supplier, or visit our website at

www.mycraftivitystore.com